To Annie C̶̶̶̶̶̶
from Mick

THE LOWRY I
KNEW

Doreen Sieja

First published in 1983.
JUPITER BOOKS (London) Ltd.
167 Hermitage Road, London N4 1LZ.
ISBN 0 906379 62 8
Copyright © Jupiter Books

Made and printed in Great Britain by
Purnell and Sons (Book Production) Limited
Paulton, Bristol

CONTENTS

Introduction

I first met Lawrence Stephen Lowry R.A. when I was aged fifteen and had begun work in an estate agent's office in Manchester after leaving school in 1942. This meeting with a man thirty-nine years my senior resulted in a friendship that was to last many years. A number of books have already been written about Lowry and his paintings and more, no doubt, will be written in the future. Although this book contains many illustrations and notes on the paintings made during the time I knew him, I do not attempt to write either a biography or scholarly monograph but purely to set down my personal memories of a dear friend.

I believe few people knew him as I did, seeing him daily for over ten years at the office, then several more years of weekly visits sharing the delight of my infant daughter; and I wonder whether anyone else received the kind of whimsical letters such as those he sent to me after I came to live in Canada.

I hope his personal friends, will not feel reproachful for what I have to say. There is the human being beneath the façade of even the noblest of people, everyone has their idiocyncrasies, and I believe his were only endearing ones.

L. S. Lowry was born on November 1st 1887, the only child of Robert S. Lowry, an estate agent, and Elizabeth (Hobson) Lowry. Mrs. Lowry was a gifted pianist, something which meant a great deal to her son and about which he was very proud. Although music meant so much to him all his life, he was unable to play any musical instrument himself.

He was a poor student at school and boasted that he had never passed an exam in his life. He joked that if his school-master called 'Born Fool!' He would automatically answer 'Yes Sir!' His frustrated mentor became so exasperated that one day, he told his young pupil the best thing for him

5

to do would be to 'put your head in the W.C. and pull the chain!' 'Yes, sir!', the young Lowry replied.

When he was twenty he went to study at the Manchester School of Art and his master was Adolphe Valette, to whom he felt an everlasting debt. He said at first Valette would say 'Very nice, lovely work', and such like euphemisms, until Lowry said 'Never mind all that, what do you really think?' When he had convinced Valette that he wanted sincere criticism, he said Valette tore his work to pieces verbally and he seldom received a favourable remark from him after that, but when he did Lowry knew that it really counted for something, and for this he was always grateful.

Recognition was slow coming to him in the art world and it was not until the 1950s, when he was over sixty years old, that he really started to gain popularity. About this time he was a visiting master at the Slade School of Art in London. He said that he was not very popular with other masters as he considered most formal lessons tended to stifle any originality a pupil might have and he had such a poor regard for exams. He used to say that the names one would see on the awards plaques at the Art Schools were seldom ever heard of again, and would tell aspiring young artists—'There is no money in it. Don't do it unless you have a private income to live on'. When he was in his fifties he was still only receiving sums such as thirty guineas for paintings on which he had spent countless hours, and which just before his death would be changing hands for thousands of pounds.

Generally speaking he had a poor regard for honour awards but he was very pleased to receive an Honorary M.A. from Manchester University in 1945, although he was sorry that his old friends and relatives were not alive to witness it because, as he said, 'they all had to work for theirs'. I remember his pleasure too, upon learning that Her Majesty the Queen Mother had bought a painting and his remark, 'what's more, she paid for it'. I had not realised that patronage without payment is often thought sufficient reward by some eminent people.

In his late adult years all kinds of awards and honours were bestowed upon him; more M.A.s, LL.D. and others which he refused, including a

knighthood. He used to tell me that the only one worth having because it could not be 'bought' was The Order of Merit (which only twenty-four living people can hold at any one time). I am not sure whether this was ever offered to him but he did refuse the Companion of Honour, of which there can only be sixty-five (excluding honorary) members.

Since music meant so much to him (he would listen to long-playing records far into the night, sometimes the same favourite piece of music played over and over again), he would have been especially pleased at the Hallé Orchestra's tribute to celebrate his birthday in 1964.

In 1965 a Christmas card showing one of his paintings, *The Pond*, the original of which was purchased by the Tate Gallery in 1961, was chosen to be sent to dignitaries around the world, by the then Prime Minister of England, Sir Harold Wilson; and another of his paintings was used for a postage-stamp in 1967.

The BBC made a film about him in 1957 and in the recent television series *Royal Heritage*, when the Queen Mother was interviewed in her morning room, I was pleased to see in the background, the picture which she bought from Lowry all those years ago. There was also a Lowry, *The Carriage*, among the very few pictures chosen for special mention and display in the present Queen's collection.

In 1965 he was installed as an honorary freeman of Salford, and he was the first person to gain the Man of the Year award organized by the Manchester Junior Chamber of Commerce in 1966. He had been an A.R.A. since 1955 but the Royal Academy did not make him a Royal Academician until just before he reached the age limit of seventy-five. Ironically, an exhibition to honour him as the first living artist to have a major show in the main galleries at Burlington House, was being planned for the autumn of 1976—just too late, he died in February of that year.

Although most of his paintings depict the industrial working-class scene of Lancashire, he professed to have 'no message', and as long as I knew him he was always a staunch Tory. From time to time I have read articles about Lowry and his work by people who sound more like psychiatrists than art critics. Mr. Lowry would have laughed at most of it and called it 'gobbleygook'. He simply painted what he felt an urge to

paint, whether it was a cripple or a stuffed toy. 'If you want something that looks exact' he would say, 'use a camera'. But he took great pains with the design of his paintings and would freely ask advice, although not necessarily acting upon it. He and my husband got into quite an argument one day over the rigging on the ships in a picture of the Mersey at Liverpool. I kept out of the discussion, although I did not see how John could be wrong having been a seaman for ten years. On this occasion Mr. Lowry did not like the criticism and insisted that the ships were depicted exactly as he had seen them. They both became a bit ruffled but as I said to John later, Mr. Lowry was probably in one of his contrary moods. Sometimes he could be like that about some minor matter and almost peevishly refused to budge an inch about whatever he had asserted. It could be irritating at times but only frustrating to argue with him while he was in that frame of mind, so I had resigned myself to letting the matter drop if I got into such a discussion with him. He would drop it too, and after he had cooled off would generally become conciliatory pleasant, I think he realised he could be cussed at times.

He neither smoked nor drank alcohol; never owned a car, and when he finally decided to have a telephone in his house towards the end of his life, because of his age, he would not have a bell on it: he said they were a nuisance, 'they don't ask permission to ring'. He was proud of the fact that he was a northerner who had remained in the north and wrote out a list for me one day, of talented people who came from the north of England. Another matter of which he was proud (to my personal regret) was that he had never left the British Isles, even for a holiday.

He told me that when he was in his twenties he had a friend in the insurance business who badgered him to take out a life insurance policy. Finally for the sake of peace and quiet, he agreed, took the medical and 'never heard another thing about it'. Mr. Lowry never enquired; he said he would see the man from time to time but the matter was never brought up again. They obviously did not think he would live to be anywhere near the eighty-eight years he attained before his death on 23rd February, 1976. He also said at that same period of his life he used to spend his money as fast as he received it, until an elderly jew, with whom he

sometimes had lunch, asked, 'so if you were to die tomorrow your parents would have to pay the cost of your funeral?' The idea so appalled Mr. Lowry that he started to save and continued throughout his life, so that his estate, at his death, amounted to approximately three hundred thousand pounds. He would tell me, 'your best friend is your bank-manager'.

He was always gentle and kind, and lived, I think, as closely as a human being can, a blameless life; and that in itself, I feel, is no mean distinction.

Chapter One

The office door suddenly burst open and a tall angular man in a shabby cotton raincoat and well worn trilby hat came striding through. His glance rested briefly on me then through the doorway (which always remained open between the inner and outer offices), as he contined on around the counter, somewhat to my consternation as I thought he must be a tenant from one of the poorer properties. He removed his coat with rather a twirling movement, rolled it into a ball, dumped it on a bookcase in the corner, ignoring the coathooks, and put his hat on top of it. I had realised by now that this must be Mr. Lowry who completed the office staff, and who, I had begun to sense I was being 'warned', would soon return from one of his frequent trips to London. It did not take me long to realise that Mr. Lowry was something of an eccentric and that he had been spoken of kindly but jocularly, in order to prepare and reassure me about a very unusual gentleman with whom I was to spend my working day and who was to become a very dear friend. Months later he told me that his impression as he came through the door that afternoon, was 'Ah, that's a bit better'. Apparently there had been an office girl for a brief time before I arrived but she had absconded leaving a discrepancy in the petty cash.

The Company we worked for had originated as the private estate of a Victorian gentleman which, as Manchester developed, came to encompass rented houses of varying degrees of poverty and affluence and also city blocks of offices and warehouses. It remained a private company, the descendants of the Victorian gentleman being the shareholders and 'the Family' were always very civil towards us employees, having a friendly few words with us whenever they had occasion to come into the office. The estate agent in charge of the office was Mr. Fletcher, a dear old gentleman who in his rare moments of exasperation would blurt out

expletives such as 'confound it, where the elephants can it be?' Quickly followed by, 'If you will please forgive the swear words'.

He was always very kind to me and one day as he passed through the office and saw me powdering my nose, he murmured something which I did not quite hear. 'That was nice', said Mr. Lowry. 'What did he say?' I queried. 'Gilding the lily', he replied.

When Mr. Fletcher's sixtieth year with the Company came around we were all invited, along with the shareholders, to a dinner at the Grand Hotel in Piccadilly, Manchester. Mr. Fletcher was seated on the right-hand of the Chairman, and myself, being the youngest member of the staff, on his left. I remember the Chairman asking me whether I was going to finish my glass of sauterne and upon my saying 'no', had no qualms about germs but said, 'well it's a pity to waste it', and drained the glass himself. The Chairman's father seldom acknowledged our presence but he was then already in his eighties. He always wore a black suit and a wing-collar, was tall and thin and I used to think that he looked like a long, bent, black stick. His dry, rasping comments, would be emphasized by wagging a boney white finger in the air. 'Uncle Ben says . . .' we would mimic later among ourselves, likewise waving a finger.

Another more endearing, elderly Director, whom we used to call Uncle Will, would cycle in from Buxton, about twenty miles away, in a knickerbocker-suit. He would get concerned about my frequent colds and strongly urge me to take cod-liver oil. He had written rather a dry book about his travels in the East. 'It would have sold a lot better if only he had got a bit of sex into it', our office manager used to say with a smirk.

Yet another member of the Board was a rotund, cheerful and rosy gentleman, whose speech was generally a little thick since his call at the office was usually preceded by a call at the pub. One member of the staff remarked that he had never known this man to say that he had ever had poor holiday weather, and he supposed it was because 'the day must always look rosy through the pink-tinted glass of the bar windows'. He was kind though. On one occasion soon after I went to work for the Pall Mall, he was coming along the back street behind the building and caught me (dressed in my usual office garb, complete with nylon-stockings and

high-heeled shoes) shovelling coke down the shute to the boiler-room. The coke was dumped on the pavement and the two janitors had to move it to the basement, one on the street shovelling and the other in the basement raking it down. One of the men was absent from work that day so the other poor lame chappy (he had one leg shorter than the other), was going from basement to street trying to do both jobs. The office used to give them an extra ten shillings for this chore and I had gone down to deliver it to them. Seeing poor George's predicament I shouted down, 'stay there and rake whilst I shovel'. We were nicely into the swing of the thing when along came the director. He did not speak, just gave me a nod and I thought, 'oh dear, now I've done it, letting down the dignity of the office', but after the next Board Meeting, to my surprise, I got a raise in pay. I do not know whether he went into details for the more sedate members of the Board, but I was told afterwards that he had praised me as a, 'very willing and helpful young lady'. I was relieved, to say the least, and very happy about my increase in wages.

The outer office was rather shabby apart from the high, solid, polished wooden counter, mahogony wainscoting running under the windows, and a large glass-fronted bookcase containing law-books (which I only remember seeing opened once).

There was a large round pendulum clock on the wall beside the fireplace, which I used to have to climb on the counter to wind-up with a key every few days. When I finally found the exact position it needed to run correctly I made a mark with a pencil on the wall, because if it was moved during the winding so that the pendulum became the slightest bit off balance the clock would slow down and stop after a few hours. Then Mr. Lowry would consult his pocket-watch, holding it at arms length, but even so could not be sure of the correct time and I did not possess a watch until he decided to rectify this deficiency and bought me an Omega wrist-watch when I was twenty-eight years old. I have it still and it keeps good time.

The counter was L-shaped with a half-door in the angle of the L. On the end of the counter sat a large, heavy Victorian mantel-clock, I should think any mantel would have collapsed beneath its weight, since one could

scarcely slide, let alone lift it. No one knew how it arrived and it had sat there since time immemorial never issuing even one tiny tick to my knowledge. There was a row of coat hooks on the wall and a set of old wooden bookshelves. The wainscoting was a sliding-door behind which was a honeycomb like set of slots, each containing folders of correspondence for the respective properties. Nobody had done any filing for years before I arrived and there was a great pile of letters crammed into a drawer, the folders were covered by a layer of sooty dust so thick that it literally slid off with the aid of a duster. There were holes in the linoleum and an extremely tattered rug in front of the tiny fireplace which was the only source of heat in that draughty room. On the mantelshelf sat a candle in a crude metal candlestick-holder which Mr. Fletcher sent me out to purchase at Woolworths one day after an electricity cut. Sometimes in winter, for fun feeling like a character out of one of Dickens's novels, I would light it and cup my hands around the flame, they would get almost numb resting on the cold paper of the ledgers as I did my book-keeping, because the temperature in the office seldom reached even the minimum of 60°F. stipulated by the Labour Laws as mandatory for sedentary workers.

One day I tripped on the ragged hearth-rug and Mr. Lowry caught me in his lap, with a laugh. He had a very big nose and I had often threatened to pull it and now, as I turned to look at him speculatively, he said 'go on, give it a pull', so I gave it a good-natured tweak and skipped away. It was not long before I discovered to what that rug owed its ragged condition. The mantel over the fireplace was just the right height for Mr. Lowry to lean his shoulders against, sometimes scorching his trousers and making a most effective fire-screen, as I used to tell him whilst I shivered in the corner. There he would stand, staring out of the window, talking whimsically, and from time to time bashing his heel against the poor old carpet and dented fender. After a few years it was replaced but it did not take long before the new one was showing the same signs of wear as its predecessor, and the heels of his shoes would get worn to the uppers.

Re-fuelling the fire was quite a ceremony when Mr. Lowry was in a cheerful mood. The pieces of coal had to be balanced on the blaze so that

the grouping was symmetrical, and if I had put a piece on which he did not like the look of, he would quickly snatch it off again and replace it, never using the fire-tongs and in the process nearly burning his fingers which he would then proceed to wipe down his trouser legs. Since he did not believe in the dry-cleaners, he thought they took all the body out of the fabric, his .appearance was generally far from immaculate. Then he would ask me playfully whether Mr. Somebody or other (a master of design whose name I cannot remember) would not be better pleased with that arrangement.

He teased me constantly in a very kindly way, and because of this furthered my education a little, which was probably partly his intention, although he did like to tease just for the fun of it. He would often, a propos of something I had said or done, say 'I don't know what Mr. Herbert Spencer would say about that'. I held off for a long time before asking him who Mr. Spencer was, but at last, overcome by curiosity, as he knew I would be, I asked him 'who was Mr. Herbert Spencer?' 'Why-a great thinker, child'. I really made his day with my next question, though he nearly choked on his laughter and reminded me of it for years to come. 'What did he think about?'. 'The perfect rejoinder', a friend to whom I recently recounted the incident remarked, but at the time it was completely ingenuous.

He would drop names and quotations from time to time and I invariably rose to the bait. He and Mr. Fletcher, who was likewise a cultured gentleman, were alike in this and between the pair of them over the next ten years, introduced me to all kinds of literature, art and theatre, which I would have otherwise, probably neglected. I was, however, rather annoyed with Mr. Lowry on one occasion. On a lovely Saturday afternoon, when I would have much preferred to be riding my bicycle in the countryside, I reluctantly agreed to go with him to the Manchester Opera House to see *The Beaux Stratagem* by George Farquhar. To my surprise I enjoyed it enormously and had been eulogising on it for about ten minutes on our return journey to the bus-stop, when I suddenly realised some of the innuendoes in the play and exlaimed, 'gosh, but it was rather shocking'. Mr. Lowry laughed and said, 'have you only just realised that? It is quite disarming though because of the beautiful

language'. I said I would like to read some more of the Restoration Dramatists, so he lent me a set of beautiful copper-plate editions, cautioning me to take great care of them. I returned them to him at the office, in due course, neatly wrapped in brown-paper and string as they had been given to me. A week or so later he was rummaging around looking for them in the large untidy boxes of papers he had on his desk. Had I returned them? I was quite positive yet he was doubtful. Many years previously he had left a bundle of drawings on a train and they had never been recovered. I wondered whether he had left the books on the bus too. Eventually he found them at home, but never apologised for his fuss and doubting. I wonder where those drawings got to and whether they will ever turn up (a little gold-mine!) stuffed away in some recess of the home of whoever found the homework of the, then unknown, young art-student.

My parents were fond of music and singing. It pleased my father to recall that he and Isobel Bailey's mother were once members of the same choir, and how young 'Bella' used to come and wait for her mother after choir practice. In the thirties one could get a seat in the cinema for four pence an adult and two pence a child, and we always tried to see the popular musicals of that era—Deanna Durbin, Grace Moore, Paul Robeson, Richard Tauber, Jeanette MacDonald and Nelson Eddy are names that spring to mind as favourites. We enjoyed light opera too, but theatre-tickets were too expensive and also involved a bus or tram fare. Some times on a Sunday evening, my father would bring out an ancient gramophone with a large wooden-horn, and a decrepit suitcase full of old records, and, in the intervals between winding up the handle, would sit enchanted by just about any sound of music from the *Anvil Chorus* to a boy soprano trilling *O for the wings of a dove*. There was the suspense of twiddling the 'cat's whisker' on the old crystal-radio which a more affluent relative had cast off in our direction, and taking it in turns with the headphones; and the darkening room as the gas 'went', with the frantic search for a penny, then the run along the dim passage to the meter before we would get plunged into just the flickering light from the fireplace. This was the modest home (overlooked by a mill across a twelve-foot alleyway)

where Mr. Lowry first used to visit me. The simplicity of the surroundings did not seem to bother him at all. He used to say, 'it is the people that matter, not the place'.

The background music at the cinema very often had a snatch of classical music running through it, which I would invariably pick up and whistle quietly to myself at work. If Mr. Lowry heard me he would remark, 'so you like Boccherini' or Handel, or whosoever's tune I had been rendering, and so enlightened me to the fact that I could enjoy classical music. He learned that I had never seen ballet and asked me would I like to go next time a Company came to Manchester. But before we ever went anywhere he would always tell me, 'be sure to ask your mother if it is alright'. I was a blond, plump, buxom teenager. Reserved, terribly shy and embarrassed about my ample figure (5'5" and 10 stone 4 pounds), but unsophisticated, because this caution held no significance for me and seemed rather superfluous. However, I always did as requested and asked Mom if I could go, and she would invite Mr. Lowry to tea before or after the show depending on whether it was a matinee or evening performance. As I got older, becoming a little more worldly-wise I understood his caution, and he said, 'now you see why I always said to ask your mother if it is alright'. After the show if there was time to spare before his bus was due, we would have tea at the Midland Hotel, or even at the rather sleazy cafeteria above Littlewoods department store, depending on time and which was the closer.

When I had been working for the Pall Mall Property Company for some months, I met a former childhood friend on the bus. When she learned where I was working she said that she had once applied for a job there but did not quite like the idea of working in an office where all the rest of the staff were men. I had not given it a thought, but felt privileged to have worked there and not only because of Mr. Lowry. I was also very fond of Mr. Fletcher, who was eleven years older than Mr. Lowry. One of his hobbies was growing roses (or more accurately, instructing his gardener on growing roses) and during the appropriate months of the year there was always a glass of water with one or two gorgeous blooms on my desk, which he used to bring to compare with a fellow rose-grower who

travelled on the bus with him each day. (He was nervous of driving his car into the city). Several years later when I was married and had a small garden of my own, I remember telling him proudly that I had bought a rose bush. The idea of a garden with only one rose-bush gave him a great deal of amusement and he gave a good natured chuckle and shook his head and said, 'a rosebush!' each time he passed me during the rest of the day.

He was a dear person and when there were just the two of us in the office, he would often sit at Mr. Lowry's desk and chat with me. In his spare time he enjoyed playing the organ at the church and projects such as trying to discover and plot the route of the old salt road through Britain. If I happened to ask him a question about something he was not sure of (English windows was one), he would spend the next few evenings doing research and tell me all about his findings, sometimes bringing me a book on the subject, at our next chat.

He was extremely 'proper', and at one time began tracing his family tree with great enthusiasm. Then we heard no more—the matter was completely dropped—and I overheard some humorous speculation in the office as to why he suddenly lost interest. His life was ruled rigidly by the clock. A day's outing would be meticulously planned down to the minute when he would leave point A, arrive at point B, and on to point C, etc., and not least of the enjoyments of his day would depend on the successful achievement of this exact schedule. The clock could be set by his daily routine:– arrival at the office 9.40 a.m., Boots library 10.30, lunch promptly at 12 noon, return at 1.50, and bus home at 3.30 p.m. He valued routine with nothing changing, and would complain that his housekeeper moved things in his study when she was dusting. 'Why I've even had to tie the paper-weight to my desk with a piece of string!' He grumbled one day.

He did not have a great deal to do at the office, he was there chiefly as a consultant. Sometimes to keep himself busy he would decide to write to the Manchester Guardian protesting or applauding something or other, and he would make a long hand-written letter on scrap-paper, with lots of asterisk notations and 'follow the line' instructions, for me to insert as I

typed it up later. Unfortunately, it always seemed to me that he got these inspirations at our busiest times, around Quarter Days, when there were hundreds of rent-notes and envelopes to be prepared and send out; or at the year end, with books to be balanced, and income tax schedules prepared.

He used to buy season tickets to the Midday Concerts and sometimes gave me a ticket. On one of these occasions the concert was to be an organ recital at the Manchester Old Town Hall and he told me to go and be sure to have a look at the frescoes by Ford Madox Brown in the concert-hall which Mr. Lowry had mentioned previously. (They are impressive paintings and visitors from all over the world come to see them). I used to buy his 'Punch' and 'The Listener' each week, from the crippled news vendor on the corner of High Street, and he always left them in the out office for me to read. He had a beautiful 'old world' courtesy. At Christmas he always sent an extra half-crown for the news vendor.

Mr. Fletcher had married late in life and his wife who had been a chronic invalid, died a few years previous to my arrival at the office; they had no children.

Mr. Lowry's desk and mine faced each other, with the fireplace wall running behind his chair and a row of windows along one side of us. The offices were on the top floor, it was pleasant, light and airy, with a view of the open sky outside. Perishing cold in the winter months with only the tiny fireplace for warmth, apart from an ancient electric heater which I would switch on when I became desperate, and sometimes I wore my overcoat too, but Mr. Fletcher, though very kind, did not approve of this extravagance or of me wearing my overcoat in the office, though he did once comment that, 'you look well in navy-blue' (the colour of my coat), perhaps to disarm me.

I do not think either Lowry or I would have stayed as long as we did if it had been cramped, with another brick wall and windows closing us in across the road. As it was we had a view of undulating roofs and chimney-pots of various shapes and sizes, and a broad expanse of sky to gaze upon.

Some days Mr. Lowry would wheel in cheerfully, bundle up his coat as usual, then stand a few paces off and try to toss his hat on to the top of

it, picking it up and trying again when it landed on the floor, and when it finally reached its goal exclaiming, 'jolly good shot sir!'. Then he would sit down, tilt his chair back as far as possible, making dents in the wall, whilst I waited for the seemingly inevitable crash, which miraculously never came, stick a well worn pair of shoes on his desk, either close his eyes and ask, 'what have you got to tell your poor old uncle, child?' Or close one eye, and with a twinkle in the other, peer out of the window and try to tease me about something or other. On other days he would come in obviously morose, at these times I would ignore him until he came around, which generally did not take too long. He said one day, 'you're a good girl, you never bother me when I don't want to be bothered'.

The Pall Mall office hours were 9.30 a.m. to 5 p.m., Monday to Friday, and Saturday morning, which we took in turns. The times were a little flexible, we each had our set of books to do and rents to collect from the weekly properties, and so long as this was accomplished no one seemed to mind that Mr. Lowry came in around 10 a.m. or took a day or so off to go to London on art business. Also he never took a regular holiday time in the summer like the rest of us and was often still there at 5 p.m. when we left. His official capacity was as the company cashier but he collected some rents and his observations in the process often provided him with subjects for his paintings. If he happened to drop a small coin on his rounds, he would not be bothered to pick it up, the local urchins soon realised this so it was no surprise that there was often a straggle of children accompanying him along the streets. He was not at all interested in the business side of our office life, it was definitely a chore to him, but he understood shorthand, book-keeping and also did some typing. None of it terribly efficiently because he simply was not interested, but everything was done adequately and we all got along splendidly in our personal relationships.

Both he and Mr. Fletcher disliked fountain-pens and ball-point pens, when they became popular, and refused to have anything to do with them. Mr. Fletcher wrote a beautiful script but Mr. Lowry's handwriting was a barely decipherable scribble. When Mr. Lowry was doing his books he used a pencil, we always knew which was his because it would be well chewed at the end, and he would walk around, looking very harassed,

with the pencil between his teeth. He completed the ledgers in ink, sticking his pen viciously into the inkwell and shaking it out behind him so that the surplus ink splattered the wall and floor behind his chair and his fingers became well stained in the process. I learned shorthand at night-school but never used it as Mr. Fletcher preferred to take his time composing a letter and would pencil it out at his leisure. One day, to my horror, Mr. Goodfellow, the Chairman of the Company, came into our office and asked me to take a letter. I can remember as though it was yesterday, my trembling search for a pencil and paper, and the playful, amused tweak he gave my waist. I took down the letter in a jumble of longhand and shorthand, but instead of feeling relief when Mr. Goodfellow left, I could have burst into tears as I wondered how I could ever make it out. Mr. Lowry came to the rescue. He had been present and could remember and even read my shorthand notes, better than I, and we soon had the letter set out reasonably as intended.

George and Billy were the caretaker and lift attendant, respectively, at 6 Brown Street, where the Pall Mall Offices were located. George was short and stocky. He had one leg shorter that the other as a result of an accident he had suffered years before when he worked in a steel mill. Billy was short and puny and had a bent leg from a hip injury, but they always wore smiling faces. They had shiny bald heads, although I did not realise this for several years because their heads were always covered when I saw them. Billy wore a large flat-topped liftman's hat, which looked as though it might try to engulf his tiny form; and George wore a nebbed cloth-cap perched over his round cheery face. It came as quite a surprise the first time I saw them with their two glossy scalps exposed, so neatly round and naked they looked like the bald domes clowns sometimes wear.

Every so often, to break the monotony, they would amble into the office and lean their elbows on the counter, their heads reaching just a little above it. They would give Mr. Lowry and me a saucy grin, while he would give me a wink, and George would start to tell us something he thought amusing, trying to get it all out so fast that he would stutter and get mixed up, but not seeming to mind a bit that Mr. Lowry would roar with laughter at him. (They thought Mr. Lowry a little odd too). The

sight of them never failed to cheer him up, he thought they were like a pair of music-hall characters. Mr. Fletcher was saddened when he learned that Billy would sometimes eke out a few pence from his pittance of a wage to bet on the horses. 'He would do so much better to buy a few seeds for his garden', he would say. Poor Billy—he lived in a miserable row-house, close to the city centre, where if even a blade of grass showed itself among all the soot and grime, it would seem almost a miracle. At times Mr. Fletcher seemed somewhat encapsulated from the harsh realities of life.

During the war, all the men in the building had to serve on the fire-watching rota. Each night two or three had to stay and be prepared, in case of air-raids, to extinguish incendiary bombs if they fell on the building. Thank goodness none ever did because with the odd assortment of people we sometimes had on duty, if an emergency had occurred it would have resembled a pantomine more than a rescue operation. Another amusing character who served on this rota, was a young man whom the government later insisted on conscripting into the army. He was a pleasant looking, amiable fellow, but we all knew that he was not quite 'all there'. For example, he would prepare the tea-tray for his father's office staff, leave go of the tray to open the door, and be surprised that the tray had crashed to the ground instead of remaining suspended in the air. He looked quite smart in his uniform, and always like to sit beside me on the bus if we chanced to meet on our way to the office. Of all the units for the army to decide to assign him to, the army chose the artillery. We all just prayed that he never had to carry any live ammunition. They kept him about a year before deciding they would manage better without him and sent him back to us and our fire-watchers team.

A room in the building was equipped with bunks, blankets, stove, etc., to accommodate the firewatchers, but Mr. Lowry refused to associate with the others in this respect, and preferred to sleep on the hard wooden counter in the office. He forgot his key one night and climbed on the rim of a firebucket filled with water to try and reach through the fanlight over the door. It tipped over of course, and drenched his feet!

He had refused to be a War Artist—said he could not bear to be sent to serve in a submarine, or such like, and the thought that he might have

to sleep with someone else made him shudder. I have the impression that he enjoyed the company of women (unsalaciously), but felt inadequate with most men. Not inferior, nor the reverse, but not quite in accord with them somehow. Even my husband (later) used to say that he always felt there was some reserve and caution when he talked with him, that he did not observe with me. He had been terribly shy as a child, so he said, wanting the earth to open and swallow him rather than be noticed. Perhaps this self-consciousness still lingered with him in adulthood.

Late one evening as he was going across Piccadilly, Manchester, he noticed a group of young people in uniform coming towards him, they looked agitated and worried, obviously something was troubling them and as they came closer one of them caught his eye and realised his interest. They stopped and a young woman hesitantly approached him and explained their problem, while the rest of the group cautiously gathered around them. Apparently they were on a weekend leave and had to be back at their base in a few hours time but for some reason or other were short by about eighteen shillings of the means to get them there. (At this time Mr. Lowry's wages at the Pall Mall would have been about seven pounds a week). I can just imagine that tall, rather shabby, odd looking man, watching and assessing them. His face now would be quite serious and the look in his small blue eyes shrewd and calculating. He gave them a pound-note and he said their relief was a joy to see. They started to give him their identification which he refused but he gave them his, and wondered silently whether that would be the last he would ever hear of them. A couple of weeks later he received a letter of thanks and a Postal Order from them through the mail. He was pleased to know that his sympathy had not been misplaced and returned the money to them.

A personal appeal like the one just related, could reach him, but apart from his generosity to the Bennett Street Sunday School, to which he had a sentimental attachment because his father had been a Sunday school superintendant there, the only response a canvasser for a charitable organization would receive from him would be 'I live in an industrial area'. The validity of this excuse often puzzled Mr. Openshaw and myself. (Mr. Openshaw was the other member of the staff in the outer

office, he had been conscripted into the Air Force but rejoined us after he was demobilised).

Mr. Fletcher was an old dear in this respect. We had people on the Company books who were chronically 'in the red' and every so often Mr. Fletcher would get on the war-path and decide he was going to see one old delinquent in particular, who had a small office in our building. After a while he would come back looking a little flushed and entirely deflated and when we asked, 'how did you get on?', having a pretty good idea ahead of time what the answer would be—'I lent him a pound'. At other times he would be quite determined that somebody or other was definitely not going to get any further concessions, but if they came into the office to see him personally we knew that the game was up. Inevitably soon afterwards we would learn that 'due to the special circumstances', to use his own words (what was special about them no one ever fathomed), he had agreed to whatever they wanted. He realised his weakness (or was it a virtue?) and one afternoon as he and I sat talking, he said, 'Miss Crouch, I would rather be taken in by the unneedy, than pass by where the need is genuine'.

When I became eighteen years of age I had to register with the government as eligible for war-work or the armed forces. Mr. Fletcher was very worried that he might lose me and wrote letters to the appropriate Ministry explaining why he felt I was vital to the operation of the Pall Mall office. Mr. Lowry too was concerned that I might have to go into the armed forces with the harsh life that might ensue, and he told me later that he had spoken to some of his friends 'in high places' to arrange that if I should be conscripted, I would soon after be offered a commission, presumably intending to aid me financially to accept. He may have got the idea of doing this from the experience of another young friend of his called Margaret. He came into the office cheerfully one day and said, 'I just met a little soldier, she said hello to me in the street just now'. It had taken him a moment or two before he recollected having met her at cousin Grace's house. 'Poor little thing lost her job so she had joined the army'. He kept in touch with this young lady and over the years unfolded her story to me as follows:–

Margaret and her mother were friends of Grace's and they had been comfortably off until her father died suddenly while Margaret was still a schoolgirl and her mother, although suffering from a heart condition, had been obliged to take a job in a bank. Grace was a spinster and quite well-off, but she had told Margaret's mother, in no uncertain terms, not to expect any help from her. They found her manner rather offensive and instead of their former warm friendship, they became estranged. Margaret had to leave school and found work in a solicitors office. She did not like it and before long they fired her, so she joined the army. At first she fared very badly in the forces and became quite ill. To make matters worse, she had a very mean N.C.O. Since she never had any spare cash, she would spend her time in such places as public art galleries. One day, as she stood looking at a picture by Mr. Lowry, another young woman in uniform came up beside her and commented on the picture. Upon learning that Margaret knew Mr. Lowry, she invited her to have tea with her and they gradually became good friends. It transpired that this young lady, who I will call 'Miss B.', was a wealthy patron of Mr. Lowry's. Lowry told me that Miss B's home (which she later gave to the National Trust) had been requisitioned by the Government and she had joined the army but did not want the responsibility of a commission. She had an uncle who was a high ranking officer and realising with sympathy, Margaret's poor health and misery in the army, Miss B made her an allowance, Margaret obtained a commission and was soon assigned to the uncle's personal staff. Margaret was a quiet, reserved person, by nature, but also due to her state of health, preferred tranquil pastimes like playing cards. She began spending a lot of her free time with the uncle's wife, they did not have any children of their own, and she gradually became like a daughter to them.

Through army affairs Margaret also met another young officer, who admired this quiet, reserved young woman, and as time went by he asked her to marry him. Margaret's physical condition from her previous illness made it very unwise for her to ever contemplate having children but he explained that his own health was poor and he simply wanted a wife who would be a good companion. He was a wealthy man in private life but the

uncle and aunt never wanted it to be thought that Margaret had married for money, so they made her a present of twenty-thousand pounds, which was a great deal of money in those days.

One thing which amused Mr. Lowry very much was that the unpleasant N.C.O. under whom Margaret had suffered so much, now came under her command. He could imagine how she must have squirmed, but Margaret had no thoughts of revenge, in fact she said she felt uncomfortable about the situation and just tried to ignore it.

Meanwhile, back in 1944 there was the prospect of my being conscripted, and I really rather hoped I might go into the army and get away from my humdrum existence for a while. However, it was not to be, my country did not 'call me to arms', and my only war-effort was spending my summer holidays along with my friend Hazel, lending a hand on the land, which in our case meant working on a farm getting blisters and sunburn, picking potatoes and making hay-ricks. I became acquainted with Hazel as we queued together one night, for the tram-car to take us home from work. We recognised each other as having attended the same high school although we had never spoken to each other before. From this meeting sprang a friendship which has lasted to the present time. It used to amuse Mr. Lowry to see Hazel and me together because she was rather thin and I was rather fat. Hazel had a penchant for lots of make-up and colourful clothes, whereas I inclined towards navy-blue and black. One day, at lunch-time she bounced cheerily into the office wearing a cherry-red coat with big beige lapels, purplish gloves, a bright scarf and green handbag. I was about to don a small angora wool cravat which my mother had made to tuck inside the neck of my coat. Hazel greeted me with, 'what a funny looking scarf, Doreen'. Mr. Lowry started to laugh and I thought he would die on the spot of apoplexy. Hazel looked puzzled and I did not want to upset her by pointing out her own bizarre appearance, so I just shrugged and let her put it down to Mr. Lowry's eccentricity. She and I would have our little differences, and I would grumble about her to Mr. Lowry. One day, to test my reaction, he started to criticize her too and I immediately went to her defence. 'I thought that would fetch you', he said. 'You are not going to let anyone fault find with

her, are you?' He often used to say 'the proper study of mankind is man'.

Chapter Two

I started working for the Pall Mall Co. in 1942. I was nearly sixteen years old and Mr. Lowry was fifty-four. I was born in one of the houses on the property (Mr. Lowry told me later that he remembered me as the child at the end house, who was always ill with bronchitis). One day at home, my mother answered the front-door and was surprised to find Mr. Fletcher standing there. She invited him inside and as they sat chatting he started bemoaning that he was obliged to collect rents himself again because his junior accountant had been conscripted into the armed forces (Mr. Openshaw, who later came back from the wars and completed our amicable threesome in the outer office). She repeated their conversation to me later. School was getting me down at this point, and there was lots of talk about ones 'war-effort', so I telephoned Mr. Fletcher and he said I could have the job. I do not know whether my parents were glad or sorry about this. I had gone to High School as a scholarship pupil, so a fine had to be paid, their income was small but they said I must make my own decision and I decided to leave school. I have never regretted the decision which brought me into contact with these lovely and interesting people.

Mr. Lowry was living in Station Road, Pendlebury, in the home he had shared with his parents since 1909. His father had died in 1932 and his mother was an invalid for many years before her death in 1939, he had been utterly devoted to her and her passing left him devastated. Although their daily house-keeper, Ellen, had been with them since she was a girl and she and the Lowry family were fond of each other, Lowry never stayed away over night but always returned home in time to prepare his mother's evening meal, and the strain upon his health became so great in the thirties that he had a nasty bout with carbuncles. His mother was reluctant to be parted from her son for even a brief time until the doctor

explained to her that unless he took care she might be left with no son at all; and so Mr. Lowry took his first short holiday in years.

Lowry's talent had been recognised in some parts of the art world, and his work had been accepted regularly in the late 1920s, by the Salon d'Automne in Paris, then recognised as the art capital of the world, but as late as the forties he was still quite pleased when he sold a picture even though it only brought thirty guineas. I remember him coming into the office one day and telling me, 'Liverpool have bought a picture', elated at the sale but rueful about the price. In later years when he would hear of these same pictures changing hands for thousands of pounds, of which, of course, he received not a penny, he would remark that he knew now how the horse must feel after winning the race when the jockey is given the cup.

He gradually became more famous but it did not mean nearly as much to him now that his mother was not there to share his triumph. Sometimes he would say 'what does it matter, they've all gone', meaning the friends and relatives of days gone by, to whom he would have liked to proved himself, as I gather that some of them had thought him of little account, since he lacked their formal academic education. He had two cousins still alive, with whom the Lowry family had kept in fairly close contact throughout the years. Grace who was a spinster, and her sister May who was a childless widow. Grace lived in Rusholme, Manchester, and he seemed fond of her in an exasperated sort of way. They frequently had lunch together at the Manchester City Art Gallery's restaurant and they invariably seemed to get into a quarrelsome argument, about something or other, while they were about it. At other times he would say 'I must have a good lunch today, I'm having tea at Grace's, she always gives me sardines and she knows I hate them!' He thought Grace would have liked them to share a house together, each with their own rooms, but there was no way he was going to chance that. 'I'd be throwing pans at her in no time at all', he would say. Of all the people I heard him talk about over the years, so that I felt I almost knew them personally, she is the only one I ever met. She called in the office briefly one rainy day, I offered to lend her my umbrella but she refused pleasantly. I suspect she was just

curious to see the office-girl Mr. Lowry had probably told her about. (He used to get annoyed with me when I spoke of myself depreciatingly as 'only the office-girl'). Grace died of cancer not long afterwards and then he realised how he missed her.

Her sister may still be alive and for some reason his remarks about her were invariably catty. He seemed quite gleeful that she had unsuccessfully tried her hand at chicken-farming and that she could not evict the tenants from her rather lovely home but occupied a little house at the end of the driveway 'and shakes her fist at them as they drive by'. He would make dreadful remarks about her cooking, saying 'I defy anyone to get their teeth into one of May's cakes', then add that she had a diploma in domestic science. I do not know why he spoke of her in this way, it rather troubled me at the time. She seemed to be a little eccentric too, he said once she came to visit his mother for a few days, bringing along with her two cats a dog and some hens in a crate. He remained unrepentant and in a letter to me dated 2nd April 1963 (but postmarked 1964!) he writes: – 'I did a very terrible thing at Christmas, did I ever tell you that cousin May has a wild cat that she has tamed completely? Well I am very fond of that cat, and it dislikes me intensely, and when it isn't trying to fly at me and scratch me—it just sits and looks so contemptuously at me that I feel uneasy—for that cat understands. Well every Christmas I send it a nice card with a pussy cat on it, trying to pacify it, but this year I sent it a beautiful one, but unfortunately forgot to send cousin May one. So now I am in complete disgrace'.

I was curious to see his home on Station Road, and one evening after work, persuaded him to take me there. We went to Sisson's Cafe in St. Ann's Square and had mushrooms on toast for tea then had to shiver in the dusk at the terminal waiting for an empty bus which remained obdurately on the other side of the road, the conductor only condescending to make its destination known and allowing us to alight and escape from the drizzle and cold, about two minutes before it was due to leave. I suppose the dismal evening and the gas-light in the house added to the gloom of the surroundings, and the portrait of his mother, painted in 1910, hanging in the living-room, seemed to have a presence of its own.

This remark pleased him, and sometimes he would remind me of this impression I had. It was not at all the type of stark portrait one generally thinks of in connection with L. S. Lowry, but beautiful and painted in the traditional academic style which some people have doubted he was capable of doing. There was a portrait of his father too, but I did not like this nearly as much, it looked carelessly done by comparison with his mother's. He said these portraits would go to Salford Art Gallery when he died.

In the gloomy passage from the front-door there was a row of hooks on which hung several old coats and hats, one of which was a deerstalker type cap. I wondered whether there were any workmen about but he said they were just old coats he had discarded and left there. He showed me around the drab, cheerless house—his mother's bedroom where they must have spent so many somber hours together and I wondered how Mr. Lowry had ever developed the bubbly sense of humour he so often brought forth. From what he told me his parents were very staid people and his father even rather uncommunicative. When Lowry, as a young man, had mentioned to his parents that he would 'like to have a car', his father's only terse comment was 'the man's mad'; and that, was that. Lowry seemed to know very little about his father's family, except that his father had a brother who died. On an outing he and his father took one day, he said his father stopped across from a particular house and stood and looked at it for a very long time. Lowry senior did not make any explanation for his interest and although his son was curious, their relationship did not seem to permit his asking 'why?'

As we were leaving the house I remarked upon a still-life painting in the living-room and he said he had done it as a student—would I like to have it? I refused it because during the years I associated with him he was always rather suspicious that people wanted something for nothing from him and were on the 'scrounge'. I sometimes wondered when he asked me would I like to have something I had admired, whether he suspected I might be another of these and I never wanted him to even suspect that our friendship for him was based on anything other than affection, because I always had the feeling that basically he was a very insecure and lonely

person.

The house had only been rented to the Lowry's and about 1945 the people who owned it decided that they wanted to live there themselves, but the Tenancy Act prescribed that suitable alternative accommodation had to be found for the tenant. How Mr. Lowry could move into that tiny terraced house around the corner on Chorley Road for nearly two years I do not know, except that he kept saying he felt guilty at keeping them from their home (this despite the fact that he had lived there himself for nearly forty years and they had only comparatively recently bought the house), and he even left that still-life on the wall when he moved away because the lady who was moving in had admired it.

Life in the office went on much as usual, the busy times were around Quarter Days and in the slack time between Mr. Lowry and I would often take a late lunch-break. I had to go to the bank for the Company, then we would meet at Sisson's in St. Anne's Square where Mr. Lowry would buy coffee and cakes (a lovely treat in those days of austerity). If there was time later, or sometimes after office hours, we would browse around the antique shops and art galleries. One day I told him that I had seen a pair of beautiful little vases on Deansgate. He asked me whereabouts and later in the day he returned to the office and handed me a small parcel. In it were the little Bloor Derby vases I had admired earlier; it made me feel very pampered.

I mentioned to him that as a small child, on one of my trips to the Manchester City Art Gallery with my father, I remembered seeing a lovely painting of a lady in a long green dress, which I thought of as 'The Green Goddess', but I had not seen it since. He said, 'that would have been a Rossetti, he is out of fashion now, though he seldom comes on the market and would cost quite a bit. I must try and get one one of these days'. He did buy several in later years but I have not seen them because it was after we came to Canada. He went on to explain that Rossetti's friends had chided him that he could not paint a picture without including beautiful ladies in it, at which Rossetti had protested and said that he would paint one—*The Bower Meadow*. Inevitably when it was finished there were the lovely ladies as usual, and Mr. Lowry and I made a trip to

Manchester Art Gallery to have a look at it.

My parents had framed prints hanging all over the house, nine in each of two downstairs rooms and several in the bedrooms. The one on the upstairs landing Mr. Lowry noticed was of Elizabeth Siddal, Rossetti's mistress. Making the beautiful oaken frames for all these prints had been my Grandfather's hobby. Sometimes Lowry would bring a painting into the office and ask me, 'what is wrong with that?' I would protest that I knew nothing about painting, to which his reply would be that this was precisely why he was asking me, because I would not get bogged down with technicalities and he would badger me until I gave him an opinion. He did not always agree with my comments but one picture in particular which I do remember criticizing that it was in two parts 'like a doughnut', and he exclaimed 'by gad, you're right', and subsequently altered it, was *An Island* 1942, purchased later by Manchester City Art Gallery. I think this was the first of his pictures to be made into post-cards and sold in galleries around the world. He was so pleased one day when he received one of these posted in Australia.

His own portrait of 1925, beautifully painted like his mother's, sat in the corner of the office for months and I kept telling him to move it before it became mildewed or damaged by the cleaners, but he did not seem to care. It now hangs in Salford Art Gallery.

I was impressed by the stark outline of the bombed out church near All Saints, which I could see from the bus, as it went along Upper Brook Street, on my way home from work each night, so on one of our walks together I took him down to see it and that resulted in another painting of a now vanished piece of old Manchester.

I was fond of dancing and he took me to a Ball at the Manchester School of Art. I remember how self-conscious I felt at having to take his arm to guide ourselves along the dark, unlit war-time streets, and how amused he was that the Principal, idiotically as I thought, kept referring to me as Mrs. Lowry. We did not dance together but I caught sight of him watching me as I danced with a young East Indian student.

One day, as we were looking around an antique shop where he was well acquainted with the owner, I admired a Dresden ornament of *The*

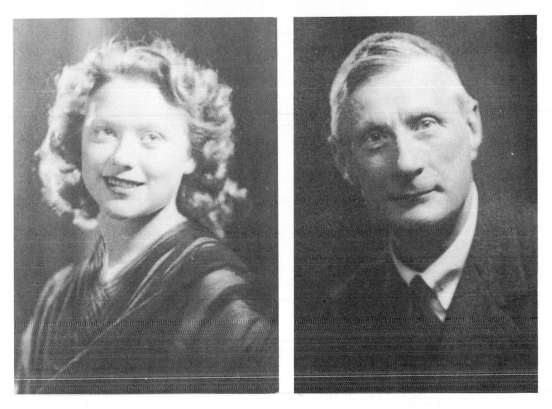

Portrait photographs of Doreen and L.S. Lowry.

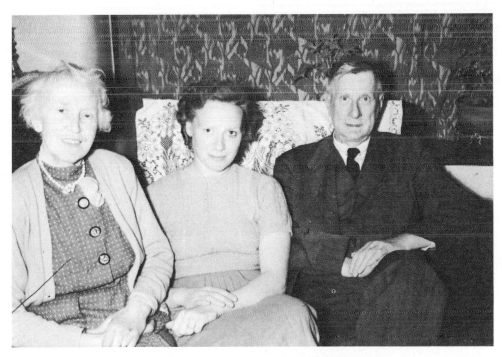

Doreen and her mother with L.S. Lowry.

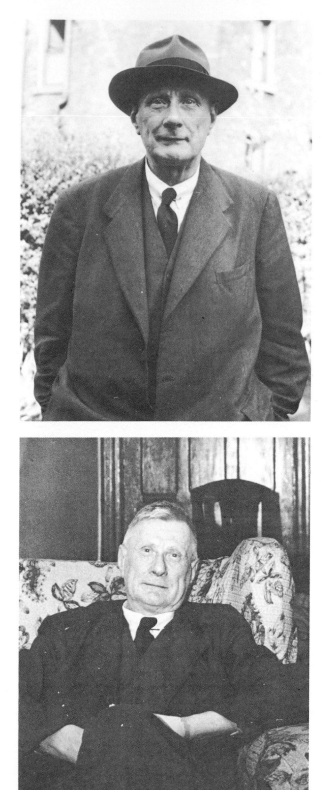

Three photographs of L.S. Lowry taken at different times when Doreen knew him.

(*opposite top*)

One of the 'fuzzy' wedding photographs showing Doreen, her husband John with her father and L.S. Lowry.

(*opposite bottom*)

Doreen and Lowry.

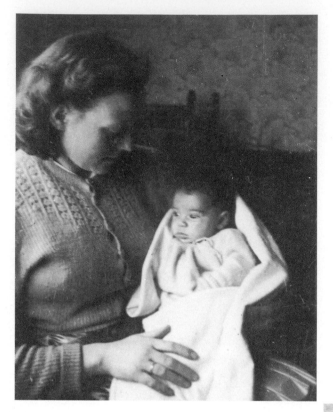

Doreen with the new-born Christine.

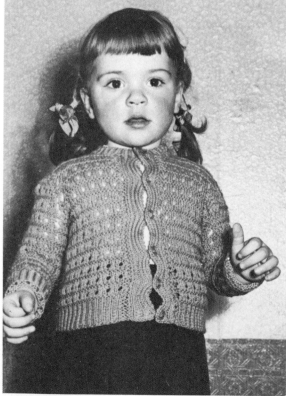

Christine aged about four years.

Clifford Openshaw.

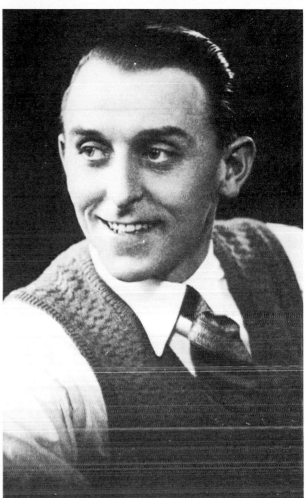

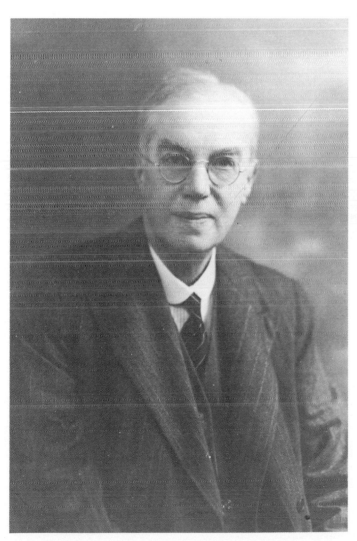

Mr. Fletcher.

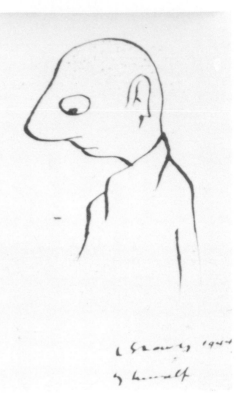

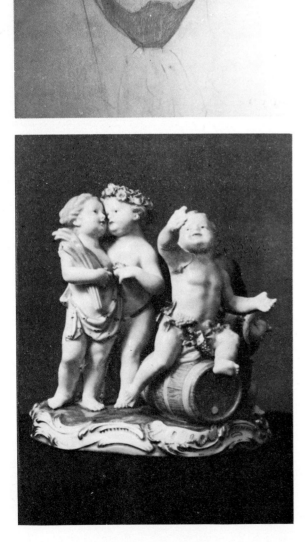

(*above left*)

Portrait of a tramp by L.S.Lowry given to Doreen.

(*above right*)

Caricature sketch of himself by L.S.Lowry.

Dresden ornament of the Four Seasons given by Lowry to Doreen.

Sketch of a Fylde farmyard.

The following pages contain a selection of reproductions of Lowry's letters to Doreen.

The Elms.
Slatymdge Road
Leatham Ashbre

Dear Owen

I was very pleased to get
your letter. Yes the Show was a
true success. but the Inland Revenue
takes a very big slice of it. It is
dreadful. Over here with
me matters are really going on just
the same here. except that I am selling
a lot older. my dislike for work is
just as strong as ever. but it is best
for me to keep on... I don't feel I could
ever make such a trip as going out
of England now I am quite past
that sort of thing — I was most
interested at what you say about
Christmas in Cathedrals & I will
at the very first opportunity, send

a look. over to you - I know there are small
books - and if ever there is anything you
would like me to send, do please let me
know. I I will be delighted - and also
if I am not an absent friend, by then -
+ Christine should come over I I
should love them happy to do what
I could to make her stay pleasurable - +
I am sure your cousins would be
very pleased.

At. 6 Bruns Street Mr Fletcher
is wonderful. Our friend Mr Chenshaw
is pretty much the same as ever -
except that he is beginning to gad
about rather more than before -

By the way I have sent to you
a copy of a new book about me by
Mr Mervyn Levy - Published by Studio Books
but of course I have sent it to
No 63 instead of to 72 - my
memory is becoming deplorably bad. -
I hope you are keeping well as can be

Ann is growing up into a very serious young lady — & Carol Ann is now 17 & is a little [flighta^tho] — she can be very nice indeed when she likes, but she has still that intense dislike for work. It almost makes my feel that she must be a member of the family — her dislike of work is so acute. — If you dont receive the copy of the book sent to no. 63 am mistaken — let me know & I'll send another to the <u>right address</u> — I am glad your son is keeping you fully occupied — too much leisure is not so good for ^one^ at 74 I am working harder than ever — My friends tell me it is a good thing — I dont agree — I hope you get this in time for your Birthday — & that you have a very good Birthday — Best wishes to John & the Children
Yours L Spring

2 April 1963

Dear own.

I think I owe you a great many letters. I am very
ashamed of myself. but the fact is I am getting old + at the best
I was never a good letter writer. I am shocked I didn't write at Xmas time
+ fully meant to. but I was so very busy with quite a number of things that
didn't really matter very much that I hadn't any time for the things that did
matter. and I did a very terrible thing. did I tell you ever that
cousin May has a wild cat that she has tamed completely. well I
am very fond of that cat., it dislikes me intensely + when it isn't trying
to fly at me + scratch me - it just sits + looks so contemptuously at me that
I feel uneasy. for that cat understands. well every Xmas time. I send
it a nice card with a pussy cat on it. trying to pacify it. but
this year I sent it a beautiful one. but unfortunately forgot to
send cousin May one. So I am now in complete disgrace. when I
told her. one cannot think of everything. it didn't make any difference
So I am in worst disgrace. Well all that is something that will I
am sure bore you to death. I am sure -

Mr Fletcher is ageing now. he cannot walk about hardly at all.
+ I fear to Beaver Street will never see him again - Mr Taylor is
just the same. but Clarence. Mr Openshaw, seems to get younger +
more buoyant every time I see him which isn't so often. for I
am so busy with things. - one thing + another - that I don't often get
into Manchester now. I am getting older suddenly somehow - +
on top of that. Manchester is changing. + soon will become.
hardly recognisable - Round Common Street + the back of Piccadilly
in particular

How are you all - I suppose you are quite settled there
now - + how is Christine. what is she going to do afterwards
+ is she coming over to this part of the world - + Richard

will be getting a big fine bouncing boy by now are you ever going to come over here — + How is John Matters are about the same here. — I get up in the morning + work + go out in the afternoon generally & sometimes come back + then go to bed wondering what it is all about. Ann is just the same except that she is 31 now nearly 32 + no signs of a boy — boys have come + go but her Father + Mother are now quite reconciled to her becoming a spinster like her Fathers 3 sisters + her Mothers one sister. They were + are all spinsters & to my mind dont do too badly on it tho her aunt in Musselburgh died two years ago nearly & we never seem to want to go to the Festival now — it wouldn't be the same — One died ann, was taken

her death rather badly — She was very fond of her aunt,

I am frankly not as much ... as I was done up to 3 or 4 months ago. I am alright & pretty active for my age — but as soon as I begin to think & work... I at once begin to feel very tired and I am very relieved at that.

Have you heard from Mr. ... or Mr. Fletcher lately? I suppose you know Mr. Harris is dead — He died quite some months ago — it might be a year. The P.M. still have the annual lunch — this year it was yesterday but I couldn't go — for I had a caller here from a long way off. I am always callers from somewhere or other. I am fed up with callers — They are beginning to get on my nerves — I made a fatal resolution not to answer any letters some time ago — but that only matters worse — for instead of writing — they come & they dont go too quickly some of them.

I dislike Meltham more & more — & between Meltham on one side of the road — they are hurry up many too many houses — Skyscrapers and all that sort of thing an american gentleman who comes occasionally to see me — expressed astonishment & said that quite a little part now looked more like Manhattan than anything else & he didnt

seem to think much of Italy. I have said I may [?] set
out of this terrible place for years – in fact ever since I
came. I have a strong feeling for Sunderland – sea
front & go a lot – it is a splendid coast line –
Durham & Northumberland & quite important & the
Tyne is a wonderful river for shipping

well I can't think I have told you very much after all –
I hope you can read – and I must say it is
very good of you to write as you did in spite of
my inactivity.

Hope you all as well as can be.
yours
LS Lowry

The
Elms,
Slaybridge Road Nathan's in Berghere neck
Cheshire

Dear Doreen.

I am afraid my letter writing is terrible — I don't seem to write letters now —
I keep on receiving them — and on my part — my writing is terrible —
Nathan seem to go just as usual here. The weather seems to get worse — I
didn't nothing — more news — no better seems just the same as ever
in Sheephams neither sheep & few months ago — been a good time to trim
anyother Father.

"I wanted to send Christine something. That she would like because you
give me an idea — would it be a brush a train and yourself for the new
for putting your hat?" and Christine be coming me to the country
in a "year or so". You don't mention in a letter some little time ago
that she might be doing so. I am afraid I am getting much less
active in myself toward an I get older — but people tell me I do very well for my
age — I don't know but I suppose I do — John the the changing winter
so much — Had I go as little as possible now — the Southend they life I have gone to
Malaya for 3 years the was offered an appointment there then is getting John
to the is 31 years now, takes very little to bring now — but whatever she is still the
same — little Carol been a race in our Shirland. and proud for interested lad
boy & is now at Bromley College, but in London town is John & the little boy
He seems to be a beautiful child. Keep you all in order — I am sure —
hope you are all keeping well — and the weather with your crooked hands

Four Seasons. Mr. Lowry wanted to buy it for me and after some hesitation I consented to allow him to do so. The shopkeeper was pleased and remarked 'I am sure the young lady will not be ungrateful'. I glanced at him and something in his expression made me wonder what kind of interpretation to put on that. I suppose there might have been some speculation as to our relationship and looking back now and remembering some of Mr. Lowry's remarks and responses around that period, I wonder to myself what exactly his sentiments were towards me.

Compared to his usual great reserve with people, I suppose for him his behaviour towards me was rather intimate. He would stand in front of me, place his hands on my shoulders, tilt his head back slightly and look me full in the face. I would ask what was the matter, wondering whether there was something wrong with my makeup, (of which both he and Mr. Fletcher mildly disapproved, although I was never one for plastering it on) or my hair, which he did not like when I had it cut and permed once a year. As the perm grew out I fastened it in curls or a bun in the nape of my neck, and this he liked, but when he saw it after a perm he would moan, 'oh child, you've ruined your hair again'. I was naturally quite blond in those days and sometimes he would say, 'how is little Blondie?' Teasing me because he knew I did not like the name.

At other times, when I was working on a ledger, he would come and stand behind my chair, lean over and grip my shoulder hard, and make a remark such as, 'are you doing your sums correctly child?'

Occasionally I would glimpse an unusual expression as he looked at me and would ask, 'what are you thinking about now?'. It would vanish immediately and he would reply, 'you are very quick', and go on to talk about something else.

I looked up at him one day across the desks, wide-eyed for some reason, and he said pleasantly 'don't look at me like that'. 'Like what?' I responded, puzzled. 'Big eyes', he replied. I expostulated and felt annoyed that he would think I could be so silly as to be coquettish with him but I have begun to wonder since whether he did not think it so absurd.

It never occurred to me to regard myself and other members of the

office staff in terms of being different sexes, we were just companionable together. Messrs. Taylor and Openshaw would crack jokes sometimes, at which they and Mr. Lowry would laugh uproariously and at the time I truly did not understand at all what they were laughing about, and this would amuse them all the more. It was only years later that some of their salacious wit 'dawned' on me.

Soon after Mr. Lowry met Margeret again he used to tell me that sometimes young A.T.S. friends of hers would call at 117 Station Road if they were in Manchester, because being in the army, they were 'always glad to sit on the hearthrug in front of a roaring fire or have a hot bath in a private home'. It never occurred to me that there was anything odd or unusual about this, or to question as to why they did not go to their mothers's. I took everything at its face value and never doubted anything he told me, but now I wonder whether he made them up, so that his friendship with a young woman like myself would not appear strange to me.

When I was seventeen he had a professional photographer make portraits of us. I was rather prudish because when I saw mine, I thought I was over-exposed and asked to have my neckline filled in. He was very kind and had the photographer make another less sensual portrait.

He was a great admirer, and often talked about Charlie Chaplin, who had recently married a very young wife. He repeatedly mentioned Margeret and her husband who had recently married 'just for the sake of companionship'. I put no construction on this at the time, just now in retrospect, I wonder.

He came into the office one day, soon after I had told him that I was thinking of getting married, and started to question me. I had never seen him so agitated and troubled and although I remember feeling a little annoyed and uneasy at the time, I did not attempt to analyze why, but silenced him by answering, rather sharply, that I had always thought that I could confide in him and he would lend a sympathetic ear, without judging or condemning. I was very fond of him but was rather immature, naive and perhaps insensate in some ways.

During the forties there were shortages of everything, including oil-

50

paint, and sometimes Mr. Lowry would come rushing into the office with the news that John Heywoods or an art-supply shop in Albert Square had just got some in stock and would I go and see if they would let me have some flake-white. This was the colour with which he always thoroughly coated his canvases as a base for the painting. Mr. Lowry would say 'that lady in John Heywoods has taken a positive dislike to me and won't let me have any'. On our lunch-break, I would enlist Hazel to come and buy some too. I think the old dear in John Heywoods got a little suspicious the way I always asked only for flake-white, she asked me one day whether I was an art student and I answered in the negative. I do not know whatever she thought I did with it, and wished he would sometimes ask me to buy another colour also, but he never did, flake-white was the only colour he needed so much of. The lady in the shop continued to let me have it, although she did look somewhat doubtful at times. There was rather a cadaverous looking old man in the other shop though, and he would leer lasciviously at the buxom young wench I then was, and after a while I told Mr. Lowry that I was sorry but I simply could not go into that shop any more. He said, 'that's alright, I understand', but I do not know whether he ever did.

Mr. Frank Fletcher, Mr. Fletcher's brother used to look into the office from time to time. He was a pleasant man, fond of telling a joke, and Mr. Lowry would some times spend a few days at his home and I would be invited along for tea. Frank was always referred to as 'Poor Frank', by his brother, because of his lack of success in the business world, but he always seemed cheerful and contented. They were a musical family and between Mr. Fletcher, Frank and his son Philip, played just about every musical instrument. Mr. Lowry told me, with a mischievous twinkle in his blue eyes that at one time Frank was a travelling salesman for tombstones, 'but he got tired of carrying around samples', and would rub his hands together and roar with laughter at his joke. Frank bought several of Mr. Lowry's paintings at a time when he received little other encouragement, including a stark portrait of himself which, unfortunately, the rest of the family did not care for and would make rude remarks as to where it should be hung. It too has finally come to rest in Salford Art

Gallery.

As I got to know Mr. Lowry better I began to remonstrate with him about his appearance. His clothes were originally of good quality, and his suit well cut according to his own requirements (he liked them baggy), but they had become threadbare and shabby. He could smile at himself in this respect and told me one day that he had been in a public lavatory when a man began to carry on dreadfully about the condition of the place. Mr. Lowry agreed with him all the way until the man said, 'well what are you going to do about it?', at which Mr. Lowry, naturally, became rather annoyed, 'now look here . . .'. The man, who had thought he was the caretaker, apologised and Mr. Lowry recovered sufficiently to grin as he told me about the incident later.

He always wore black shoes. One day when he stuck his feet on the desk I could see that there was a hole right through the sole. When I told him about it he just folded up an envelope and put it inside the shoe. He wore grey socks (which I usually bought for him from Marks & Spencers), a dark suit, always a black tie, with a narrow gold pin holding a white collar which might be well worn but was always freshly laundered. A union-shirt and a white handkerchief stuffed into his jacket breast-pocket, which he would pull out at times with a great flourish and subject his poor nose to a very strenuous rubbing. He would brush his trilby hat carefully but wear it until there was a little hole in the front fold. His overcoat was not helped by the fact that he did not like his shoes to be dusty and if he could not be bothered to get out the duster, would put his foot on the desk and hastily give them a rub with the lining of the bottom of his coat. He washed himself in the gents' washroom down the passage, talking to himself and making such a splash about it that I could hear him in the office, then he returned, rubbing his face vigorously with a dreadful looking towel which he would proceed to dry in front of the fire so that clouds of steam billowed out and it frequently got scorched. When I thought about it, I would take the towel home and wash it. Next he would look at himself in the mirror over the fireplace, rub his head and say, 'I think I get better looking, I really must get a haircut'. His hair was shorn so close to his head that he would liken it to a hard-boiled egg sprinkled

with salt and pepper, but he always had one tuft left at the front which I used to tell him made it look like a coconut. He disliked pyjamas, he said he only took them when he went visiting. He liked to wear a night-shirt, which was not a popular item of clothing and I scoured the town for him before finding a shop that had some in stock. These were the days of clothing coupons and food rationing and he detested the bother of it all. I believe I was the only one of his friends who got at him about his shabby appearance, because he did smarten up a little. One of the first things I did when we came to Canada and I had more time to spare, was to knit him a warm, woollen cardigan, to replace the ancient tattered thing which he brought out each winter. He never wore a scarf and when someone gave one to him as a present, or a coloured tie (when he only wore black ones) he became quite annoyed that they hadn't noticed this and declared they were 'fools'. I was constantly catching colds so he gave me a lovely warm scarf, it was beige mohair and he said it had belonged to his mother.

A couple who were most kind to him during this period, were Mr. and Mrs. Vaughan. They had a grocery shop near his home on Station Road, and he had a hot meal with them almost every night. I dread to think what would have happened if he had had to cope with the world of 'food points' and rationing, all by himself. He would have probably depended entirely on the uncertain fare of restaurants. Sweets were rationed too, but chocolate was almost unobtainable, and every so often I would find an envelope addressed to me, on my desk, containing a two ounce bar of Cadbury's chocolate. 'It is from Mrs. Vaughan', he would explain, and he would also bring some along when we went to the theatre. I used to think how very kind she was, especially when they would increase to two or three bars, just before my summer holiday, and I used to send her a picture postcard thanking her. It was only years later, when we had been to a piano recital by Mark Hambourg at the Deansgate Concert Hall and I learned that Mrs. Vaughan had also been there and had seen us from the balcony but would not introduce herself, that I began to suspect that the chocolate bars were just another of Mr. Lowry's kindnesses towards me.

My mother had been ailing for a number of years, and in 1948 she

died of cancer. Mr. Lowry had recently bought his house in Mottram-in-Longdendale and the garden was gorgeous. My mother was in the hospital for six weeks before she died and each day, before he came to the office, Mr. Lowry would pick a beautiful big bunch of flowers and bring them down on the bus for me to take to her. The nursing staff admired them and those lovely bouquets were the only bright spot in her painfilled days. He said afterwards, that seemed to have been a good enough reason for having moved to Mottram, because he often wondered later why he had taken himself away out there, and he simply let the garden become derelict.

I was now almost twenty-two years old and had made my first casual acquaintanceship with John, nearly five years previously. He was a Polish Merchant seaman and spent the entire war years (his ship was in Turkey when the war broke out) sailing back and forth across the Atlantic between America and Britain.

We met again, quite by chance, in 1947. I did not recognise him at first, but he never forgets a face. The entrance to 6 Brown Street, where the Pall Mall offices were located, was flanked on both sides by shops and on the opposite side of the street was the General Post Office. One day, as I hurried over to post some letters, I noticed a young man looking in one of the shop windows, but he watched me crossing the road and coming back again. As I re-entered the building through the big glass swinging-doors, I was feeling a little indignant but I glanced back and saw him looking through the door as he slowing walked by, we both hesitated, I had not seen him wearing a hat before but now I recognised him and smiled. We began to see each other regularly and fell in love. We could not plan a wedding due to various circumstances—lack of funds, his need to learn a trade ashore, and also my mother's poor health, which was deteriorating but we had no idea that she had cancer, simply that I could not contemplate leaving her. Under these circumstances I would not even get engaged but thought if and when the time was right, we would get married. She died at the beginning of August and we were married early in October, just my father and Mr. Lowry being the witnesses at our wedding.

John was living with friends in London just previous to our marriage and the Polish authorities (whose permission he needed to get married) were putting petty obstacles in our way. Meanwhile, in Manchester, Hazel's mother had very kindly offered to make our wedding breakfast if I could help with the rations. Offal was not rationed but very hard to come by, but, under the circumstances, the butcher said that he would save me an ox-tongue. We wanted to be married in church but John phoned me in exasperation at the office one day, to say that due to another hitch in London, we could not get the bans read in time and we would have to postpone the date. I squealed out, 'we have to get married—the tongue won't keep!' This of course gave great amusement to my friends in the office and I got kidded for ever after. They used to tell me, 'you never would have got married if it hadn't been for that ox-tongue'.

We were married on the date originally planned but it had to be at the Registrar's Office. To the horror and dismay of my mother's sister, I insisted on wearing all black. Mr. Lowry had often told me, 'you'd look well in a big hat, I'd like to see you in one', and on this occasion I wore a wide brimmed black straw, with a cream-coloured lace trim.

The weather was perfect, a beautiful sunny day, exceptionally warm for October 9th, but Mr. Lowry was late so John and my father went up to keep our appointment while I walked down Oldham Street to meet him as he sauntered leisurely up from the bus terminal.

When we arrived at the Registrar's Office we were shown into a long, very narrow room with benches down each side and scarcely knee-bending room in between. It was crowded and simply blue with smoke. My father was the only member of our little party who smoked and I thought 'oh dear, Mr. Lowry is going to fidget', because it looked like a long wait. I do not know how the order was arrived at, but it was certainly last in first out, and to my relief, in about two minutes we were ushered into the Registrar's Office. There was a long table with a row of chairs and we were told to stand to one side of it. Mr. Lowry looked miles away in thought, wearing a very blank expression and after the Registrar had addressed him a couple of times with no response, he became rather irritable and asked me whether he spoke English (as he was already having

problems pronouncing my husband's first name, which is Zdzislaw—we called him John because my father refused to attempt the pronunciation). I gave Mr. Lowry a dig in the ribs and he paid attention; he told me later that he had been impressed by the long narrow table and row of empty chairs and wondered whether there was a picture in it. When we learned a few months later the Registrar had died suddenly, he said, 'that was retribution for being so impatient with me', joking of course. After the ceremony I gave Mr. Lowry the only kiss he ever had from me. We all had lunch at a restaurant then went to Southern Cemetary, Didsbury, so I could put flowers on my mother's grave, and while we were there, admired the impressive memorial to Allcock and Brown, who were the first men to fly across the Atlantic ocean, and Mr. Lowry showed me the grave where his parents (and now he too) lie buried. Next, we made our way to Hazel's where her mother had made a tasteful reception for us. Hazel and my cousin Sylvia and their fiances, along with Mr. Hands, were the only other people invited. Some photographs were taken, Mr. Hands gave me a cauliflower to hold since I didn't have a bouquet, but there was something wrong with the camera and, except for the one of the wedding-cake (which was Mrs. Hands' present to me), they all turned out slightly blurred. Mr. Lowry is standing there with his hands in his trouser pockets, as usual.

I gathered later that my friends had thought it all rather odd, especially as, since I found that Mr. Lowry did not have any plans for the weekend, and I knew that he hated spending them alone in Mottram, we invited him to spend it with us. We were not going to have a honeymoon and he and my father always got along well together, and 'to put the icing on the cake' so to speak, he broke his false-teeth in the wash-basin the following morning and I took him for a walk.

I continued to work and go to concerts and shows with Mr. Lowry. My husband was working and also attending night-school. He found electronics, which he was studying, fascinating, and enjoyed spending his spare time building and experimenting, so he was glad that I had Mr. Lowry to take me out occasionally. We never once missed a Manchester Hippodrome pantomine, which Mr. Lowry enjoyed with an almost

childlike glee. He would say sometimes, 'they are wonderful, they are so dreadful!' He got us tickets for Manchester Chamber Concerts too and would gladly pay for any tickets to shows I bought for us.

Mr. Openshaw came back to the office when he was demobilised. He is fifteen years older than me, and like Mr. Lowry and myself, is an only child. He has remained a bachelor.

My first recollection of him is when I was about five years old and he was collecting the rent—how he pulled a handful of coins out of his pocket and they all lay in such a neat row across the palm of his hand, as he gave my mother her change. I remember asking Mom later for pennies so that I could play rentman, and trying to pull them out with the same expertise.

He is about my height and slim in build, good natured and has an excellent sense of humour, we all got along splendidly together, having a keen sense of humour and of the tragic-comedy of life, we invariably found something to laugh at uproariously, though I suspect that more prosaic characters might have at times, thought us 'daft'. I only remember him once being seriously ill, he had influenza, but he would so often come into the office with a mournful face, saying he was not well, and wearing at least three pullovers, that Mr. Lowry seldom took him seriously and would laugh and give him a slap on the back, and say 'you're alright Fred' or 'Percy' or 'Clarence'—whatever name dear old Uncle Laurie felt like teasing him with that day, because none of these names had any connection with Mr. Openshaw whose name is Clifford. He took it all in good part but would be cross if anyone else presumed to call him by a name other than his own, and he would laugh at himself when he decided to wear one less pullover and announce that it must be spring.

The pair of them delighted in teasing me. Mr. Lowry would plead with Mr. Openshaw to tell me the tale of Strange the Lawyer, because he was 'sure that I wanted to hear it', or Mr. Openshaw would insist that Mr. Lowry draw Mr. Jones in the doorway of his house. The tale of Strange the Lawyer went like this:— There was once a lawyer named Strange and when he died his name was not inscribed on his grave-stone, all they put there was *Here lies an honest lawyer* and everyone said 'that's

Strange!' Mr. Lowry would laugh joyously and got Openshaw to repeat this story to me to the point of exasperated boredom.

The drawing of Mr. Jones was in the same category as the Strange the Lawyer story (Mr. Lowry could not even resist mentioning them in his letters to me). Mr. Jones was a tenant at one of the properties where Mr. Lowry collected rents, he was rather portly and Mr. Lowry would draw Mr. Jones waiting for him—a view of doorways in an empty street with just a large round tummy protruding from one of the doorways.

No matter how I protested that they had done it all umpteen times before, the whole ritual had to be gone through, and to make sure that I would not try to escape, Mr. Openshaw would sometimes get me in a head-lock under his arm, whilst Mr. Lowry thought it was all tremendous fun. This, of course, was when there were only the three of us in the office. One day, however, a tenant from an office below did burst in upon us during one of our little scuffles. We had heard about some of his amorous escapades (through George and Billy), so if he was hoping to find some hanky-panky going on in our office too, he was disappointed. Mr. Lowry was sitting there as usual, roaring with laughter and looked rather vexed at the interruption.

Mr. Openshaw did the Football Pools each week for the lads of the staff. This was a very serious business but amused Mr. Lowry and he would grin and make a thumb at him as we closed the office at five o'clock, leaving Clifford still studiously poring over his latest system. Despite all his efforts there were never any spectacular wins, but after the few brief disappointed comments about the performance of the various teams or players once the results were known, discussion would resume on the chances for the coming Saturday. I sometimes thought that Mr. Lowry and Mr. Taylor (who was a Chartered Accountant and shared Mr. Fletcher's office), did not treat this matter with quite the reverence it deserved!

When the Test Match was being played Openshaw and Lowry were always anxious to hear the latest score, and if I had been out of the office for some reason, they would greet me on my return, with 'what's the score?' To which I would of course reply, 'what score?', and both would

howl with anguish.

Mr. Openshaw was a very fine amateur actor, he played in various productions from Oliver Goldsmith to Noel Coward, and there was nothing amateurish about any that we saw; he always gave an excellent and polished performance. In more recent years he has been directing, and here too has received excellent press notices. One play in particular which I remember going to see with Mr. Lowry, but as much for Mr. Lowry's performance as for Clifford's, was *The Matriarch* at the Central Library Theatre, in which Mr. Openshaw played the part of an elderly Jew. We always tried to get aisle seats so that Mr. Lowry could stretch out his long legs, and on this occasion Mr. Lowry kept fidgeting about and asking, 'where is he? Where is Percy?' I kept telling him that Openshaw was the little old man with the grey hair and beard to the left of the stage. But Mr. Lowry kept on—'I can't see him, I can't see him, where is he?' Indeed, he was very well made-up and his stance and whole appearance were entirely in keeping with the part. Then Mr. Lowry recognised him and was so surprised that he started to laugh, helplessly, doubled up towards the aisle, which he seemed to be in danger of toppling into at any moment. I felt so embarrassed and kept urging him to be quiet. The tears were streaming down his face and he stuffed his handkerchief into his mouth in an effort to stifle his laughter. Eventually he managed to simmer down and we enjoyed the show immensely.

This was part of his naive charm, the way that he could, with us at any rate, give way to unrestricted wholehearted laughter, whether it was such as this or when he and my father, over tea, would try and outdo each other with the most atrocious puns. My father's shoulders would be shaking with an almost silent mirth but Mr. Lowry would clap his hands and gleefully exclaim, 'oh! Jolly good sir; that was a good one; I must remember that'. And gleeful was the way he laughed, clasping his hands, his shoulders hunched, bending forward slightly and with his eyes twinkling; or mopping the streaming tears with his pocket handkerchief, and sometimes he had to make a quick grab at his false-teeth, which had a tendency to slip out at the most inopportune moments. Giving a sharp sneeze he would make a wonderful catch, as they went flying through the

air, exclaiming, 'jolly good, sir, worthy of the first team!'

This was the other side to the grumpy old artist recluse, that he showed to the world in his later years.

I do not remember Mr. Lowry ever buying a newspaper, he would not want to be bothered carrying it for one thing; but he always looked briefly through the Manchester Guardian when Mr. Fletcher brought it to the outer office and helped me to finish the crossword puzzle.

Mr. Lowry used to say that as soon as there was any change in the office staff he was going to retire. I think he stayed in the first place because everyone had to work during the war years, and then because it was somewhere to go during the day and we could generally find something to have a laugh about.

In August of 1952 I gave Mr. Fletcher notice that I would be leaving the office as I was expecting a baby at the end of the year. He seemed to take the news quite phlegmatically, even when I answered 'no', in reply to his enquiry as to whether I would be returning to work afterwards. However, as he came through the office a short time later, he looked rather forlorn and said, 'my world is falling around me today'. Mr. Fletcher was a very reserved person with no really close friends, but he and Mr. Lowry had some interests in common and would enjoy a chat together from time to time, and I suspect he realised that now Mr. Lowry would keep his threat of not staying when there were changes in the staff, and this he did, leaving a few weeks after I did.

They were both what is now rather a rare species, genteel men and delightful individuals.

I called in the office to see Mr. Fletcher occasionally, taking my little daughter after she was born, and she gave him quite a chuckle one time as she quickly proceeded to set out little cups and saucers which were a present from Father Christmas at Lewis's. As she quietly busied herself he said, 'this isn't G. and G., you know'. We never made tea or coffee in the Pall Mall offices, but took it in turn to slip out to a cafe if we wanted some. On the other hand, whenever Mr. Fletcher went downstairs to see the Company solicitors, 'G. and G.', there always seemed to be someone hurrying around with a tea-tray, and he would chuckle that it was difficult

to know how to avoid coffee-breaks. He always sent me a card and a book of stamps at Christmas, and we continued to correspond until his death a few years ago.

I always had the impression that Mr. Lowry did not want his life in the business world known about although nothing was ever mentioned specifically. I have never spoken of it to anyone who did not already know that he worked, not even the closest friends I have made in Canada over the past twenty years, although I have often spoken of him warmly as a very dear friend. Reading the newspaper articles about him since his death, I realise that I was right, as apparently friends and collectors who had known him for many years were not aware of his office job at The Pall Mall Property Company. Even his beneficiary, Carol Ann Spiers (née Lowry), who now has the letters and photos of mine which he kept, remarked in a letter to me that she had '. . . learnt a great deal about the world he knew'. I realise now that if it had been known that he had a nine till five job, he would probably have been called by that derogatory term 'Sunday painter'.

John and I bought a motorbike in 1950, and sometimes we would take a ride up to Mottram and call on Mr. Lowry. He always made us welcome and I enjoyed looking at the lovely antique clocks, furniture, and particularly the beautiful teasets and ceramics he had in his house. One group which I thought looked especially attractive, standing in the corner on a shiny, dark-wood chest of drawers, consisted of two pink Chinese vases and a blue and white ginger-jar, and he asked me would I like to have them. I was taking no chances on him thinking that I was cadging, so I said that they looked just perfect where they were at present and perhaps I would have them one day. Maybe I was also too sensitive. I do not want to give the impression that he had a mania about scroungers but he would say, 'people are always wanting something for nothing', and unfortunately this is often true. He hated people, 'waving their cheque-books around as though if they named the right price anything is for sale'. He was generous towards me, he did not like to think he was imposing on us by his frequent visits, and one of his presents to us, bought after our daughter was born, was a piano because he thought my husband (who had

recently sold his piano-accordion to buy me a washing-machine) would like to play, and also, 'it will be nice for the child to learn on later'. People would sometimes think he should give them a picture, and this annoyed him immensely, yet a schoolgirl once wrote asking him why he painted his little stick-like dogs the way he did, and expressing a liking for them, and he was so pleased that he painted one for her on a small wooden lid from a box of crystallized fruit, and sent it to her—a complete stranger.

On our visits Mr. Lowry would invite us to have tea with him, boiling eggs in a pan from which the handle had broken off. He removed it from the stove with a tea-cloth, nearly burning his hands in the process, then we would sit down to eat in his Tuscan-red living-room, off beautiful antique Chamberlain-Worcester plates, surrounded by his lovely old furniture. When he moved into the house he had had an awful time getting the walls of that room painted to just the shade of red he wanted. The poor painter had to do it three or four times and still Mr. Lowry did not think they were quite the right colour. He took us for a walk up the cobble-stoned road to the Mottram church, which stood on a slight rise and looked like a fortress on the hill, from the distance as you approached Mottram, and we would admire the lovely view of the rolling countryside and the remains of a Roman encampment in the distance. In the churchyard Mr. Lowry showed us a Victorian gravestone with a verse inscribed upon it about the body-snatchers.

At times such as these, I am sure that he was happy to be living in Mottram though in later years he would write saying how he hated the place. He showed us an illuminated-address the local council had given to him. As far as I know it remained in its box, but he was pleased that they 'had wanted to do it'.

23 Staleybridge Road was a square built stone house on the main street of Mottram in Longdendale, Cheshire. There was no garden to speak of at the front, just the space of a couple of paving-stones and a short hedge separating the house from the street. The next house was set back so that its front garden ran along one side of number 23, and the houses themselves were joined at the adjacent back corner of 23 so that the neighbour's wall, with a window, enclosed one side of the little paved

court at the back of Mr. Lowry's house. There was a rustic outdoor privy (not a W.C.) in the court, nicely surrounded by climbing shrubs and when Mr. Lowry bought the house this was the only form of toilet and he insisted that an indoor one be built off the bathroom before he would move in. My husband offered to paint the renovated bathroom for him, which necessitated him staying over night in the guest room. This was furnished with a comfortable bed and Jacobean furniture comprising a long black chest which looked like a coffin, at the foot of the bed, and a tall, wide, black wardrobe in which I could just imagine a row of skeletons dangling. Over the fireplace hung a portrait of a man's head, the stark kind that Mr. Lowry was noted for, and between the Louis XIV clock with the gong-chime recording the hours on the landing outside his door, followed by numerous other clocks throughout the house (and there must have been a dozen at least, Mr. Lowry used to say that they were company). The staring eyes of the portrait were just visible through the gloom each time poor John woke up with the result that he did not sleep too well that night.

The weather was beautiful that weekend and I went up to join them on the Sunday. We took a walk up the hill past the church and called on a local councillor who had helped to influence Mr. Lowry in coming to Mottram. His wife kindly made us tea—never knew Mr. Lowry to refuse a cup! He took milk but no sugar. When he was a young man he and his parents had taken a holiday on an island off the coast of Scotland and the weather had become so bad that supplies could not get across to them. One of the things they had run out of was sugar and he had never taken it since. He said he had loved sailing on a rough sea in a small boat and years later remembering his enthusiastic talk, I hoped he would enjoy a sail across the Atlantic in a Manchester Liner, which he could have boarded at the Salford docks (as we did when we came to Canada) and travel along the Manchester Ship Canal to the River Mersey and thence to the open sea. I thought sailing on the Ship Canal might mean something to him as he had once told me, somewhat ruefully, that his mother had invested in Ship Canal shares, which he still held and would scoff about them humourously each time he received their paltry dividend

cheque. We even suggested that he bring along a friend for company and, what I hoped would be my masterstroke since he was always complaining about income-tax, perhaps he could get the Inland Revenue to allow the trip as deductable expenses, but he never came to Canada. He was annoyed with the Inland Revenue because for most of his life painting had been a financial liability for which no allowance had been made yet, now, when he was beginning to make some money from it he was, of course, being taxed. He spoke admiringly of wealthy patrons who would simply write 'NO INCOME' across their income tax returns and live off their capital, because they thought the taxes exorbitant and refused to contribute to them.

There was a large garden beyond the court at the back of the house. The previous owners had been enthusiastic gardeners and the flowers were glorious, but after that first summer, when he bought the beautiful bouquets for my mother, he took no further interest in it except to have a man come in to trim the hedges and lawn.

Inside the house itself was as cold as the tomb, due to being built of stone, I suppose. Even when I knew Mr. Lowry would have a roaring fire going in the living-room, I always dressed warmly for a visit with him. Once through the front-door you were in a small hallway and surrounded by some of his collection of antique clocks. The stairs were opposite the door and on the right was the living-room and a passage leading to his studio and the kitchen. His studio was always perishing cold, with an all pervading smell of turpentine and was so cluttered with canvases in various stages of completion or preparation (layered with coats of flake-white that is), that he had scarcely two square yards in which to move around in front of the easel. A beautiful seascape hung in this room and he said it was for Margaret when he died. He continued to visit Margaret and her husband at their home in the north of England and would often talk to me about them and mentioned in his letters that they were both in poor health.

The bathroom was at the head of the stairs, and his bedroom to the right, overlooking the back of the house. The guest room overlooked the front, with a lovely view of the countryside from the window. Beside this

room on the front, was another much smaller room with not enough space for a bed. This held a charming little antique, kidney-shaped desk, and some sentimental mementoes of long ago, including a painting of the back of Maud, with a tennis-raquet in her hand. More about Maud later.

There was a square landing, with more clocks, and stairs leading up to the attic. Up here was just a spare easel and an oval mirror leaning against the wall. To my remark that I could use a mirror over the kitchen fireplace, he of course said, 'then take it home with you'. He would often respond like this, so I became cautious what I admired, but this obviously was not in use, or of any great value, so I accepted it.

There was a cellar beneath the house, I poked my head through the door one day, but the house itself being so cold I did not want to descend into a even chillier region.

The living-room was smallish and crowded with furniture, some antique, some old-fashioned but comfortable. His mother's piano with metal candelabra attached to the front, more clocks and cabinets displaying the beautiful old teasets and ornaments, some of which had been stored in a bank vault for safety during the war. There was a great, tall, lumbering Victorian desk in the corner, with umpteen compartments in it, one of which he said, contained a bag of gold sovereigns. One day as he dumped a photo of Christine he had requested, on the top, he said he would give one to her, but I guess he forgot. There were several paintings on the walls. The portraits he had made of his parents and paintings by other masters; but the biggest picture framed and hanging over the sacrosanct piano, was an old Victorian scenic calendar.

There was barely room to edge your way around the oak refectory table in the middle of the room, on which stood a large, gorgeous ceramic bowl. This was always piled high with unanswered letters and in later years I often wondered whether mine lay with them.

Before one of our visits to Mottram I told John that I would like to have a straight drawing by Mr. Lowry, so many people seemed to think that he could not draw a normal portrait, and we decided to ask him whether we could buy one. I say 'ask', because we had the impression that he did not want his pictures to go to just anyone—paid for or not. Mr.

Lowry seemed pleased and got out a bundle of drawings, the best one of which I thought, was of Maud, a young lady who had died about 1930, she was the daughter of friends of his parents. He did not want to part with this of course, he had often told me stories about Maud and I got the impression that it was intended for Salford Art Gallery after his death, along with the portraits if his parents. I chose the head of an old tramp who had been called in from the street to sit for the life-class in Lowry's student days at the School of Art in Manchester. He would not let us pay for it but brought it along framed, on his next visit.

The Lowry's had been very fond of Maud and her parents and often visited them at their home in St. Annes on Sea, near Blackpool. Mr. Lowry said they were kind and charming people but had shown no interest in Maud as an infant, leaving her instead to the care of competent servants. As she developed into a beautiful, clever and musically talented schoolgirl, they began to show an interest, but it was too late, and a great sorrow to them as the years went by, because she did not care about them at all; she remembered and resented their earlier indifference to her. She had no regard for her own safety whether it was recklessly playing field-hockey, insufficiently clad in dreadful weather, or tearing around the countryside in her small two-seater car which she 'drove like the wind'. 'It put the fear of God into you to drive with Maudie', Mr. Lowry would say. She had a terrible temper but could be utterly charming when it suited her to be and one day as she and Mr. Lowry were driving through the quiet roads of the Fylde countryside, they unexpectedly came upon a flock of hens which Maud had no choice but to plough through, with squawks and feathers flying everywhere. She did not turn a hair, simply drove into the farmyard, where the farmer was already beginning to curse and blast at her, but she turned on the charm, and asked what she owed for the damage. 'Butter wouldn't melt in her mouth', according to Mr. Lowry; and in no time at all the farmer was 'eating out of her hand' and solicitously examining her car to see if it was damaged and whether she needed any help.

Mrs. Lowry was already a housebound invalid by the late nineteen twenties and Maud was very fond of her, so she persuaded Mrs. Lowry to

allow herself to be driven, by Maud, to her parents home in St. Anne's on Sea for a visit. Having experienced Maud's driving, Mr. Lowry nearly had a fit at the thought of entrusting his mother to her recklessness, but both ladies disdainfully told him to stop fussing, they would be perfectly alright. Mr. Lowry gave Maud a good lecture about caution and that was all he could do about it, apart from pray. To his immense relief they arrived safely at their destination. Mrs. Lowry had enjoyed the unaccustomed outing enormously and said what a careful and considerate driver Maud was, looking at her son as though he had been hallucinating when he had told her about the hair-raising rides he had had with her.

He asked me many years later, would I drive him around if he bought me a car, but I did not have the nerve, and although I have learned of necessity since coming to Canada, I still do not enjoy driving and have a strong inclination to duck under the wheel whenever I see another car coming towards me.

Mrs. Lowry had been a gifted pianist, something which meant a great deal to her son, but she no longer had the necessary stamina to play. Maud was a talented musician and would play the piano by the hour for Mrs. Lowry, but if she came home and her mother was entertaining friends and asked her to play for them, she would say that she did not feel like it, but a few minutes later she would be heard playing a piano in her own room upstairs. When Mr. Lowry remonstrated with her about her behaviour towards her parents, she would tell him not to interfere and if he persisted, 'she would swear like a trooper', and tell him to mind his own business. When the matter was dropped she would resume her normal pleasant manner with him. Another time the local vicar tried his hand at reforming Maud. He reported her language was shocking and 'really went away with a flea in his ear!' Mr. Lowry, incidentally, would tell me at times, 'you mustn't be slangy, child', then he would use expressions like this one!

Maud was extremely careless of her own well-being and she went to watch a football match with Mr. Lowry, on a very cold day, wearing only a red pullover. He kept asking her whether she was warm enough and she kept saying that she was 'alright, and it doesn't matter anyway'. She

caught a very bad cold which she characteristically neglected, and so she died, still in her early twenties. She would probably have been the one person that Mrs. Lowry would have been happy to see her son marry, but although he was fond of Maud he had no intention of marrying her, he said, 'there would have been skin and hair flying in no time'.

Maud's father died a few years later, and her mother of cancer during the war. Mr. Lowry said she would phone him sometimes when he was fire-watching, and her final call to him was to say that she about to die, but telling him not to grieve for her. She was really the last of his 'dear ones'. She was quite wealthy and he told me that some of his antique china teasets had belonged to her.

I must return to the early 1950s. Mr. Lowry had an open invitation to our home and he generally visited us at least once a week, and he was always pleased, if he had no other commitments, to be invited to stay overnight.

When he arrived, first of all he would get warm, sitting in an armchair crouched over the fire, generally with the poker in his hand, giving it the occasional jab. He used to say that there are few houses you can go into and feel at liberty to poke the fire. Then as he warmed up and relaxed, he would lean back (still with his seat on the edge of the chair), stick his feet on the top of the fireplace, and in this 'V' shaped position, looking as though he might slide on to the floor at any moment, listen to records of classical music or talk about where he had been and the titled or famous people he had been with. It was always interesting, and I especially enjoyed the anecdotes he would tell me about various friends and acquaintances—Margaret and her husband and Ann and her family, David Carr and Mr. Bennett, to mention a few. I am sorry that I never met any of them, they are so real to me yet we could pass in the street and I would not recognise any of them.

As time went by several famous film-stars could be numbered among his patrons and he was invited to the set (and he said asked to make a poster but it proved to be unsuitable) while the film *Raising a Riot* was being made with Kenneth Moore. I was a keen movie-goer in those days, so first hand news of these enchanting people always fascinated me and I

would listen with wrapt attention to whatever he had to tell me afterwards, about them. He was clearly pleased and flattered on one occasion when he was leaving the Palace Theatre in Manchester with an actor whose fans were outside clamouring for autographs, that the actor called out to them, 'you should get this man's, his may be worth something one day'. He seldom ever went to the cinema himself but would ask me what I thought about someone such as this he had met, which was not much use really as I judged them chiefly by their glamourous looks in those days.

He was easy to please with regard to food. Egg and chips were fine so long as the chips were not soggy, but whenever possible I would grill him a lamb-chop and make some little plain cakes, which he would playfully cram into his mouth all in one bite. Stewed rhubarb was a favourite too, especially with custard and he also liked bananas when I could get them. He seemed to have an iron digestion and it still amazes my husband when he recalls how he would pop a piece of meat into his mouth and give it barely two chews before swallowing it. The he would sit at the table for a long time drinking cup after cup of tea. He invariably dried the dishes for me and despite his lurching movements, which have sometimes been remarked upon, he never broke any.

Chapter Three

My daughter, Christine, was born 3rd January 1953. The weather was bitterly cold and there was a glassy coating of ice everywhere. My father, who was rather shaky on his feet, having suffered a slight stroke about twelve months previously, braved the elements to come and see the little grand-daughter he had so looked forward to. When the nurse showed her to him there were tears streaming down his cheeks and he, of course, attributed them to the inclement weather, dear old Dad. I know Mr. Lowry was glad that we had a little girl too, and it wasn't long before he was planning that we should send her to a private school and later to Oxford. He sent me a large bunch of hothouse grapes at the hospital, and bought her a lovely silver early Victorian christening mug.

His visits continued as before except that she was a very demanding baby, always 'yarking and howling' as he would put it, which rather spoilt our former quiet evenings relaxing in the lounge listening to records. He was always a hoverer, whether helping to set the table, wash the dishes or simply leaning on the stove whilst I cooked. Even my mother used to say to him, 'for goodness sake Mr. Lowry, sit down' and give him the toasting-fork to play with. Now he seemed quite content to hover while I tended the baby. I was breast-feeding her and when first I had to nurse her, beside the fire, away from the draughts with all the family present, I felt a little embarrassed and wondered whether he would be too, he realised what was bothering me and said' 'don't worry about me, it isn't the first time I've seen that done you know'.

One beautiful day later in the year, just as I was taking in the washing from the clothes-line, Mr. Lowry arrived unexpectedly. I knew he had an engagement that day with some people who lived in a 'stately home of England', (John and I had paid a shilling each to go around it one

Sunday). I was surprised to see him, and asked what he was doing here. 'I excused myself early', he said. 'Told them I had an important engagement'. 'What are you doing here then?' I asked. 'This is it', he answered, 'I want to wheel that kid out in the park', and proceeded to help me take in the washing.

Around September of that year, John and I decided to take a quiet holiday in Knott End on Sea. As a child I used to spend my school holidays with an aunt who lived there. This time we stayed at a house on the Esplanade run by two elderly sisters. It was all so peaceful and room to spare so we sent Mr. Lowry a telegram, asking would he care to join us, which he did a couple of days later. During our visit the old ladies received the local newspaper from their former home town and were delighted to find a whole page, complete with photograph, devoted to L. S. Lowry, and realise that they had a celebrity staying with them.

John had to return home to work but Mr. Lowry and I stayed on for a few more days, visiting my aunt and ambling along with the baby-carriage. He was lying on a couch beside her cot one day, and the pair of them were taking it in turns making 'raspberries' at each other. I admonished Mr. Lowry not to encourage her in it, but the pair of them were chuckling away and kept right on with their fun.

Mr. Lowry was very fond of milk and enjoyed a warm glass before retiring at night, so on the pretext of heating milk for the baby each night, I would always manage to heat some for him too. We felt it quite a conspiracy putting one over on the little old ladies in this way. He was staunchly teetotal, and it used to amuse him when a waiter would enquire whether he wanted anything to drink before a meal, to reply with just the hint of a gleam in his eye, 'yes thank you, soup'. He said he was frightened to touch alcohol in case he was unable to stop and became like an aunt of his who died an alcoholic.

When it was time for us to return home he hired a taxi so that we could travel in comfort with the baby and her carriage. A few months later he brought us a framed painting of the Knott End Ferry. While we were in Knott End John had taken a few photographs of things which had caught Mr. Lowry's eye, (to save him making sketch-notes on the back of

envelopes, as he generally did) so I had no qualms about accepting this little picture. We also have a painting of a toy cat which I knitted for him in 1944; a small caricature of himself in my autograph-album; and a tiny sketch of a Fylde farmyard (Maud's?), also in my little autograph album.

At this time we were living at 7 Longford Place, Victoria Park, Manchester. It was a long, narrow Edwardian house, with fairly high ceilings, the front bedroom where the baby's cot was, being so far from the living-room that John installed an intercom so that we could hear her if she cried. The living-room was always warm and cosy as we never allowed the fire to go out because the hot water boiler was at the back of the fireplace, but by the time the water had traversed all the pipes on its long journey up to the bathroom it was seldom as warm as you would like it to be. We always had jackets hanging on the kitchen door, warm and handy for when one of us needed to make the necessary chilly trip along the passage, up the stairs and along the top landing to the cavernous bathroom. One evening John and I were sitting quietly in the living-room, when he got up, put on his jacket and left the room without a word. The next thing I heard was the front-door closing. I thought he must have gone to the public library down the road, but it was unusual for him to leave without saying where he was going. A moment later there was the sound of his key in the front-door lock and him laughing as he came back along the passage. He said that he had intended going to the bathroom but by the time he had bundled himself up to make the trip, he had absentmindedly gone out for a walk instead!

One evening we almost met one of the people who Mr. Lowry used to tell me about. There was a young lady named Ann whose family had become good friends of his in recent years. According to Mr. Lowry, Ann, who was another only child, had been a ballerina and her parents had not been at all happy about her choice of vocation, but it was something she had very badly wanted to do, and so she had been allowed to have her way. Her belief in her own abilities were proven to be amply correct and, although still so young (she would have been about twenty-three or four, at the time I am speaking of) she had received high acclaim wherever she had performed. Having achieved her ambition, she decided she had had

enough, and to her parents delight she left the stage and returned home to live. She was still remembered and sought after; one representative requested a meeting, thinking, no doubt, that if the offer was good enough she would not be inclined to refuse it. Ann guessed what he had in mind and invited him to afternoon tea. When he came to her parents lovely home and the maid served tea, with a beautiful Georgian tea-service, he realised that his journey would prove to be in vain.

Mr. Lowry became acquainted with Ann's father when they were both staying at the same hotel, and their friendship grew from this meeting. Mr. Lowry became a frequent visitor at their home and he painted Ann's portrait. He sent me a photograph of the painting, which I gather from his comments in a letter written to me in November, 1958, the family were not at first overly happy about; but gradually they came to appreciate that the very determined young lady which Lowry had depicted, was their daughter as the artist saw her. He wrote, 'her father says he has quite got used to it now, and her mother says—She knows what I meant—which remark puzzles me and makes me think, or try to think'.

Mr. Lowry generally got along well with young people and Ann was no exception. She enjoyed driving and he enjoyed being driven, and they both enjoyed music and the theatre, so this was very nice for them both. As Mr. Lowry mentions in his letters, Ann tried to persuade him to visit Italy. She had travelled and performed extensively on the Continent herself, but she had no more success than I did in getting him to leave the shores of Britain.

Mr. Lowry told me that he and Ann had called at our home but got no reply. The electric bell must have been out of order and they did not like to knock too hard in case they woke up the baby, which he felt would be an horrendous thing to do, as once she started to cry there was no shutting her up! This young lady's parents had given her a two-seater Rolls Royce for her twenty-first birthday so I said that I hoped they had parked it outside our front-door for the neighbours to see—the kind of remark that Mr. Lowry would appreciate. Somehow it seems that fate did not want to change the pattern of these people remaining just shadows for

me. I know we were home that evening and remembered quite clearly that the weather was quite cold and we were huddled around the living-room fire talking to my young cousin who was up from Cambridge.

Mr. Lowry always liked to see young people and would have enjoyed meeting Ian again who, when he was younger and attending Whitworth Street High School, would occasionally visit us in the office. The door would slowly open, then a head wearing a schoolboy's neb-cap with a large, owlish pair of glasses beneath, would come cautiously around the corner. When he could see that only Mr. Lowry and I were there, he would bounce in, with a huge grin of large adolescent teeth, and with his head just topping the counter say, 'hello, can you lend me a shilling Doreen, they've got films at Lewis's?' (Even camera-film was in short supply in the shops). This always amused Mr. Lowry and he would tell me to be off with him and not to hurry back. This was all the licence we needed (as Ian reminded me in a recent letter) to go off and 'intoxicated with milk-shakes and the city, see exhibitions of God knows what (one being an exhibition of Picasso and Matisse), or visit some of the Company buildings and jerk the lift up and down the shaft'. Ian would have been 11 or 12 years old and myself about sixteen. If Mr. Lowry and Ann had knocked louder that evening, my husband might have been spared the dubious distinction in my cousin's life, as being the first man with whom he got drunk—John said he had about two beers. Ian writes—'It was at some time in my late teens I suppose, that we went from your place in Victoria Park to some pub or other on Stockport Road [The Coach and Horses] and there was enthusiastic talk from John about his writing music and I writing lyrics, and there being a golden future in musicals, the idea is so bizarre—but there it was. I still have a feel for the stuffy bar, and more vividly do I remember myself crouched over the lavatory pan at home, surrounded by the stench of alcoholic vomit, my aroused mother anxiously over me, and my saying with fractured dignity, ''I must have eaten something that disagreed with me''. At least your place was somewhere to go in a youth that despite its escape to Cambridge seems peculiarly grey, especially in retrospect'. He got a scholarship to Jesus College, Cambridge.

About three years later, with the added inducement of a weekend with us, Mr. Lowry came to Ian's wedding. My aunt hired a bus for the occasion to make sure all the aunts, uncles, and cousins arrived at the right church at the right time. John, who was a keen amateur photographer, had his camera around his neck, proposing to take pictures of family and friends after the ceremony; when the young priest came charging down on us vociferating loudly that he would not allow photographs to be taken inside the church, and if any were taken he would have them destroyed, etc. etc., and he kept on, and on, and on, about it. When he finally stopped to take a breath, I told him as icily as possible, that since my husband had told him that he would not take pictures inside the church he could be assured that he would not do so. Mr. Lowry meanwhile, was agitatedly walking up and down, lurching and swerving on the turns as only he could, and muttering, 'the man's an idiot, out of his mind, a born fool!'

Victoria Park was one of the few remaining residential parks with a toll-gate and a little hut at the entrance, charging cars of non-residents a shilling to pass through, so that although many of the once beautiful homes at the end of their long shrub lined driveways, were now converted to hostels for the Y.W.C.A. or similar institutions and their elegant coach-houses converted into garages; the quiet unpaved roads, overhung by massive trees, with the footpaths running beside low stone walls and rhododendron bushes, were quite a pleasant place for my father's daily walk, and sometimes he would stop for a gossip with the keeper at the little toll-gate hut and have a cup of tea with him if the weather was chilly. One day in the spring of 1955 he went for his usual stroll and collapsed. A policeman found him seated on a grassy bank beside the entrance to one of the driveways and he lost consciousness seconds later, never to regain it. The shock was great, particularly since he had remarked that morning on how well he was feeling, and I had watched with some trepidation as he gave Christine a piggy-back ride down the stairs, not having the heart to restrain them, as they were both enjoying it so; but he scarcely had time to suffer, which was a great deal to be thankful for after watching my mother's lingering death, and he had been in the outdoors that he so

loved.

Mr. Lowry disliked telephones and would not have one in the house until shortly before he died and even then he would not have a bell on it. 'They never ask permission to ring', he would say. Even while we were working for the Pall Mall Property Company, if he happened to be alone in the office and the phone rang, he would pick up the receiver and ask, 'are you there?' Instead of dealing with the enquiry would invariably suggest that the caller 'phone back later, they are all out'.

He was not home when we went up to Mottram to tell him that father had died, so I left a note for him, but he was not back in time for the funeral. When next we saw him he said that he had guessed what the note was always saying—'What's it all for? One of the saddest things is said. My father was a man of simple pleasures, watching the amateur football or cricket games and taking his daily walk or riding his bicycle when he was able, but he did so enjoy life. Mr. Lowry on the other hand, was always saying—'What's it all for?' 'One of the saddest things is watching a group of people trying to enjoy themselves'. 'Poor little kid [my daughter], it's got all its life before it'. Or reciting from *Patience taught by nature* by Elizabeth Barrett Browning, 'O dreary life, we cry, O dreary life! And still the generations of the birds Sing through our sighing and the flocks and herds Serenely live while we are keeping strife', at which point he generally let it trail away. Although he had this gloomy attitude towards life he was never depressing to be with, except occasionally for just a brief time; then he would shake it off, for the sake of whoever his companion happened to be at the time. He could find humour in almost every situation and would make the most of prolonging the enjoyment, seeming reluctant to let the moment pass in an effort to prevent his underlying feelings from surfacing, I suppose.

Christine was a lively merry child—always singing—once she had passed the tiny infant crying stage, and Mr. Lowry always made a kindly fuss of her, bringing her beautiful chocolate animals, so nicely formed that at times they seemed too attractive to eat. He brought boxes of chocolates or crystalized fruits in little wooden boxes for us to enjoy too. She soon learned exactly how to gauge his mood and could get a twinkle in her eye

to equal his, and shout the infant mispronunciations which she knew he liked to hear, and they would both laugh joyously. But it was a serious and pleasant task to climb upon his knee if he offered to read her a Rupert Bear story, or to listen to the large, old-fashioned, gold pocket-watch, he kept in his waistcoat pocket. Sometimes I would put on a long-playing record of *Swan Lake*, and she would dance around quietly to it, oblivious of everything else for as long as it played. A few years later she would have liked to have both ballet and piano lessons but I could only afford one and we decided on the latter. Now, in her twenties, she takes both jazz and ballet lessons and surprised her teacher how soon, after starting comparatively late in life, she was able to dance on pointes. It is rather strange but with her slender figure, large brown eyes and long dark hair drawn back in a bun (looking not unlike the portrait of what now seems to be the mythical 'Ann'), her love of music and dancing (shades of Maud and Ann) she pretty well epitomizes what seems to have been Mr. Lowry's ideal young lady.

One day I left them alone together for a couple of hours while I went to the dentist. When I came home Uncle Laurie had relaxed into his usual 'V' shaped position, with Christine sitting on his head against the back of the chair. 'So that she wouldn't be in the way of the book', he explained. They both looked surprised when I wondered whether they were comfortable.

Unfortunately, Christine had frequent attacks of bronchitis and she or I invariably had a chesty cold and I was very worried lest she too developed the asthma with which I had been plagued in my childhood. We felt sure the grimy atmosphere of Manchester was aggravating our condition, and Mr. Lowry said that if John could get a job near the coast he would help us to buy a house, where he could stay with us whenever he felt inclined.

However, due to an increase in purchase tax, there was something of an industrial slump about this time in Britain, and to our great disappointment, there was no suitable job available for him. Although John admired the patience and diligence of the average Englishman he met, and the kindness and warmth with which he was received, once he

had been accepted despite him being a foreigner; even now he gets irritated by the complacency of advertising which did not shout that Britain had the finest stainless-steel razor-blades, motorbikes, or boots and shoes, etc., surpassed by none and so allowed other nations to copy and overtake her economically. In 1956 he was becoming increasingly exasperated by the rationing, queues, shortages and climate in our part of Britain, and now that my father was dead and we no longer had his preferences to consider if we decided to emmigrate, my husband's dissatisfaction increased. I did not want to hear complaints about my country's failings all my life, and there was the possibility that a change of climate might suit our little girl's health better; as the doctor remarked on one of our frequent visits, 'it could hardly suit her less', so I agreed to go to Canada. The decision was made in November 1956 and we left at the beginning of February 1957, scarcely three months later.

I have just remembered that I did meet one of Mr. Lowry's very kind friends—Mrs. Maitland. Professor and Mrs. Maitland were Canadians who had settled in England prior to the war and Mr. Lowry was a frequent visitor at their home in Cheadle Hulme near Manchester. At one of the Manchester Chamber Concert recitals Mrs. Maitland was seated behind us and we had a chat during the intermission. She had just returned from a visit to Canada, and to my astonishment said how cold she had felt since returning to England. When I enquired how that could be—Canada to me was a land of ice and snow—she said that English houses are so cold, whereas in Canada you just twiddle the little dial (thermostat) on the wall, and in no time at all the house would be several degrees warmer. This sounded to me then, almost like science-fiction, but a few months later I learned that it really is so.

When I first met Mr. Lowry he had very few friends, but now he had several very close ones, plus the 'welcome' in so many circles that his increasing fame gave him; so I did not feel that I was deserting him, as I might have felt a few years previously, but I knew I was going to miss him very much. Despite the difference in our ages, I think I used to get along better with him than with anyone else I have ever known. He was like a very kind uncle rather than a father figure, because father's admonish at

times and he was always very tolerant towards me, generally winding up an argument with, 'you're right and I'm wrong, as you nearly always are'. I never did decide what that really meant!

John and I had a frantically busy time preparing to leave England, deciding what to keep and what to dispose of, in an accumulation of household goods going back to my grandparents days. It seemed that my parents never threw anything away. 'Waste not, want not' principle, plus the miserable memory of the thirties when my father had suffered four years of unemployment. I remember so well the ignominy my parents had felt at their position. My mother's constant sewing, knitting, mending, and surreptitious bit of dressmaking for neighbours, hoping she would be paid something for it. 'Surreptitious', because officially the equivalent of any few pence earned could be deducted from the meagre dole which my father received from the unemployment insurance each week.

There is invariably someone who will eagerly take advantage of another's misfortune and I recall a fat, ugly neighbour, who used to wear her hair in two greasy coils on each side of her head, like earphones, and she enjoyed boasting of the property she owned. She asked my mother to make her a coat. Mother could turn out a well tailored garment, which she did for her, but never received a penny for it. Years later when we were no longer in need, they met again by chance, and this woman had the audacity to remark—'I never did pay you for making that coat, did I Peggy?'

Mother used to make all my clothes; shoes were always the Christmas present from Grandmother. Father was not a 'handy-man' but he used to laboriously re-sole and heel our boots and shoes. His own boots, no matter how cracked and worn, never failed to be well polished and his threadbare clothes properly brushed and tidy. What a drain I must have been on their slender resources, needing the doctor and medicine so often. The only work I can remember my father doing during all those years was charring for his sister, whose husband had a supervisory job at the Post Office, and how grateful we were when he could get my father taken on to help with the Christmas rush of mail. My uncle's nephew was Vernon Sangster of Vernon's Pools and he used to send them wonderful hampers at

Christmas time. My aunt used to share them with us, they did not have any children of their own. There were gorgeous crackers with little gold holly leaves and bells, scrumptious puddings and hams. What a rare treat they were.

The bright side of all this had been that my father had lots of time to spend with me and we used to walk to parks, museums and art galleries, partly to enjoy looking at their treasures and partly at times, to shelter from inclement weather, and we went to all the free concerts in the parks. My father was a great believer in fresh-air, especially for a 'chesty' child such as me, and when he could scrape together a couple of pence for the tram-fare, would make some cheese sandwiches and we would go to the end of the line in Hazel Grove or Didsbury, to walk through the fields or along the banks of the Mersey river, which at this point is only a few yards across rather like a wide canal. Grassy banks rose on each side with a narrow sandy path running along the top. In spring this lovely greeness would be misted over with a haze of blue harebells, so dainty and delicate that I remember marvelling how they could bow and recover so readily, in the unkind gusts of wind.

Didsbury is, or was, perhaps the most pleasant of Manchester's suburbs, lying on the border of Lancashire and Cheshire. I think of it as Howard Spring country because this is where he and his wife lived when they were first married, and he writes about the happy times they had there in some of his books. There were beautiful homes and gardens and fields with lanes winding through them to the Mersey. An old inn with a cobble-stoned yard in front, and the lovely old house which was the Fletcher Moss Museum, with its beautiful gardens. This was open to the public, free of charge, and was one of my favourite haunts. It housed fascinating small curios of all kinds; watercolours by Peter de Wint and Max Beerbohm caricatures. Not far away in a large field, was the cricket pitch and if a game happened to be in progress we would sit on the wooden forms in the shade of the trees and watch for a while, or in the cooler weather watch a football game in the fields close to the river, until our feet became too cold.

I took Mr. Lowry on some of these walks. He was not interested in

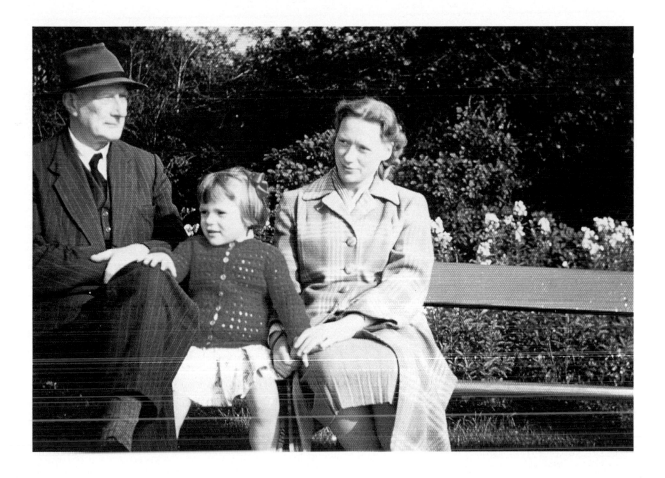

TOY CAT

1944. Oil on cardboard 37.1 x 38.2 cm.
Collection: Doreen Sieja.

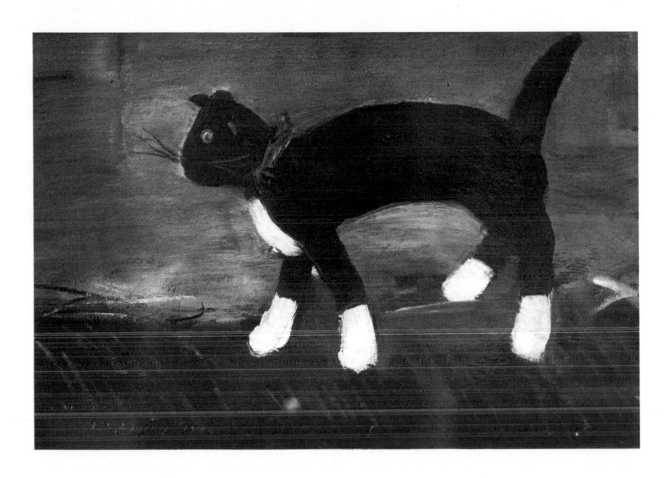

KNOT END FERRY
Oil on canvas 20.3 x 15.2 cm. Collection: Doreen Sieja.

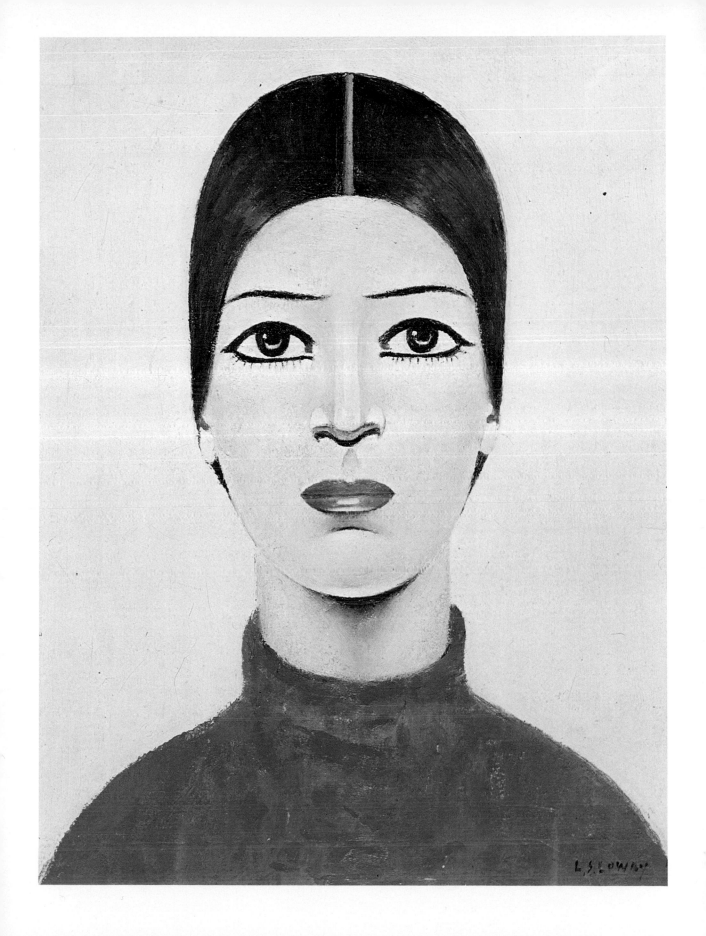

AFTER THE BLITZ
1942. . Oil on board 52.1 x 41.9 cm. Private collection.

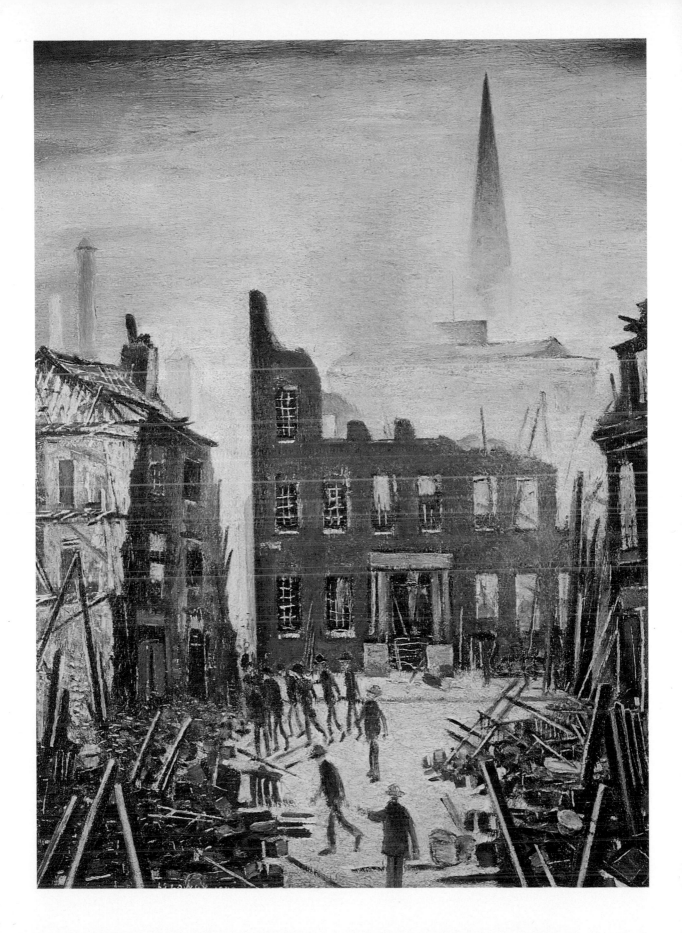

THE QUESTION
1953. Oil on board 24.2 x 15.9 cm. Private collection.

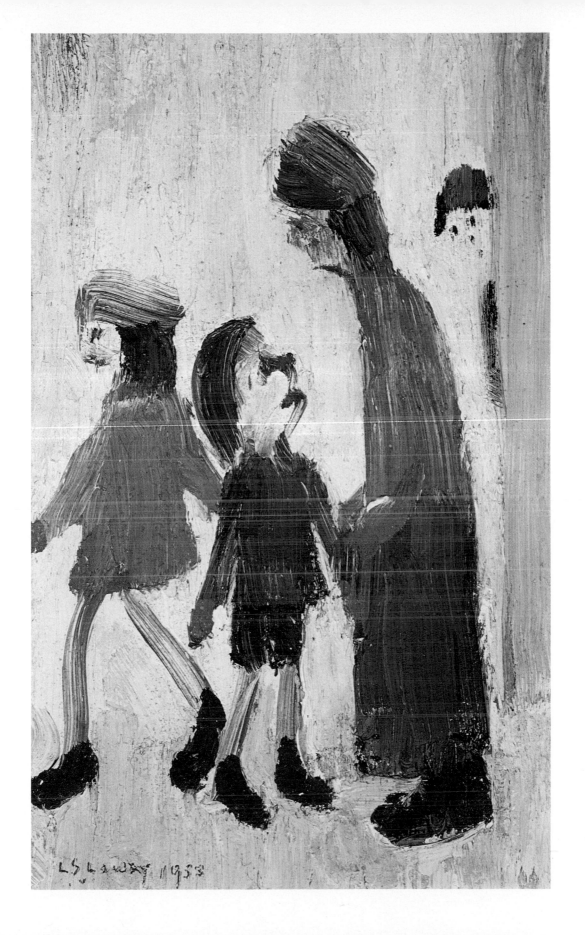

YACHTS

1959. Water-colour on paper 26.7 x 37.5 cm.
Collection: City of Salford Art Gallery.

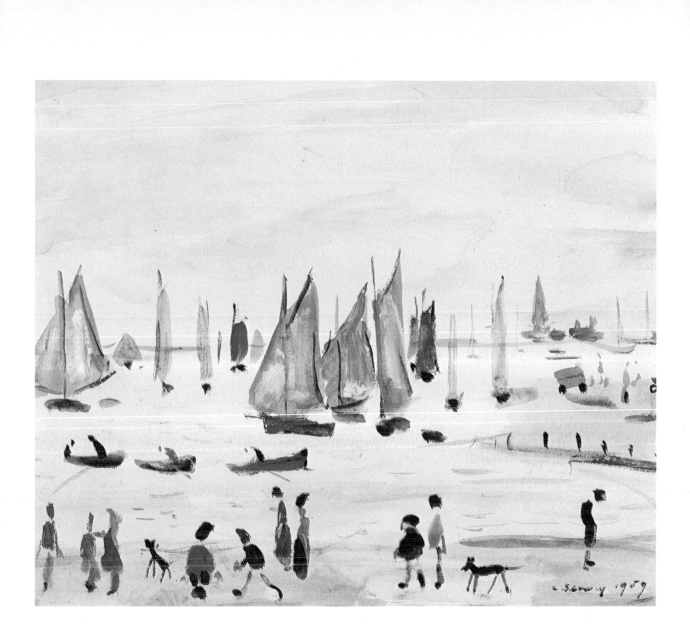

AGRICULTURAL FAIR, MOTTRAM-IN-LONGENDALE
1949. Oil on canvas 64.1 x 77.5 cm. Private collection.

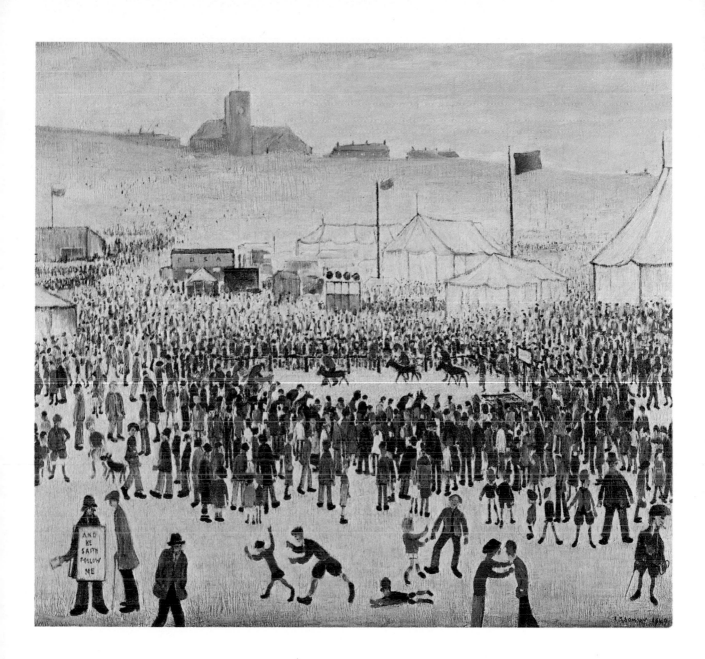

gardens, but we enjoyed browsing around the Fletcher Moss, the old churchyards, and the quaint courts and cul-de-sacs which one could still come across in some of these older parts of Manchester.

I have been digressing—John and I had started to disband our home in preparation for our departure to Canada, and I asked Mr. Lowry whether there was anything he would like to have, he just chose an old pair of opera-glasses we used to take to the theatre with us. John did not want the expense of taking furniture to Canada, but I felt that I would like to have some of my old home along, especially as selling only brought a fraction of its worth, and I could not bear to part with two or three pieces of antique china I had picked up at second-hand shops early in our marriage. Mr. Lowry solved the problem by giving us one hundred pounds for packing expenses, so we took most of the living-room furniture, including the piano.

Our last few days in England were spent with an aunt and Mr. Lowry visited us there as usual. On our final evening he came for tea and when it was time for him to leave, as was my custom, I accompanied him to the bus-stop. I still did not want to part so went on the bus with him into the city where he would make the connection to Mottram. Neither he nor I were demonstrative people, all my acquaintances from one child families seemed to have lacked this; but the bus was not due to leave for several minutes and we stood there staring at one another, he on the platform of the bus and me on the pavement, neither wanting to drag their eyes away. He looked so terribly sad and desolate and I felt full of emotion and wanted to hug him but could only grasp his hand. My throat was choked up but I finally managed to jerk out, 'you are alright now. I'll come if you ever need me'. Meaning that he would not miss simple us because now he had so many people anxious for his company. He just replied, 'you don't understand'. The bus left, and I never saw him again. When I got back to my aunt's house it was late and John said, 'I thought you must be crying somewhere'.

Chapter Four

Christine, John and I boarded a Manchester Liner at Salford docks. It was a cargo vessel which also carried about twelve passengers. The cabins were beautifully furnished and the service was good. One of our fellow passengers was a middle-aged, unmarried Canadian lady. She told me that she had crossed the Atlantic several times and preferred a small cargo ship such as this because she could be sure of getting a cabin with a porthole to herself. For a similar cost in fare on one of the Queens, she had had to share a cabin in the bowels of the ship. I have always felt grateful to this lady for introducing me to the game of Scrabble.

While I was unpacking in our cabin I suddenly realised that Christine was missing. I found her sitting on the stairs beside a middle-aged gentleman wearing an overcoat, who was busy buttoning up her dolly's dress for her. I thought how kind he was and thanked him. We were introduced to him later at dinner, he was the Captain! This little incident epitomizes the friendly atmosphere of that voyage.

The weather was delightfully mild when we left England and the trees had already donned a faint veil of green. I found the journey along the Manchester Ship Canal most enjoyable but, oh dear, it was a vastly different story when we reached the open sea. I became wretchedly seasick and could not shake it off for the whole trip. John was very disappointed, he had so looked forward to sailing as a passenger for once.

We should have disembarked at Saint John, New Brunswick, but when the ship docked in Halifax, Nova Scotia, I decided that I had done all the sailing I ever intended to do and we travelled the remainder of the journey to our final destination of Toronto by train.

Mr. Lowry frequently complained bitterly about British Railways, so I wrote and told him what a comfortable two days and a night we spent on

the train, and how delicious the Canadian apples were, which we bought from the steward each time he came past us with his snack-cart. Lowry could be quite contrary at times and now he did not like this unfavourable comparison with the British train service, and he wrote back (10 March 1957):– 'and about the trains, if you have to spend days and days on them well you naturally expect something more than if the longest time to can spend on one single journey over here is twelve hours. So there. I have got that off my chest'.

Looking back I realise what a reckless chance we took, giving up a comfortable home and John's job, to come to neither in a strange country in the middle of a harsh winter that seemed to go on for ever that year. It would be months before we saw buds appearing on the trees again, but the night sky was some consolation. In Manchester it was usually dull and cloudy but in Canada the clear starry-bright sky night after night and the occasional glimpse of the aurora borealis, was a glorious sight to behold. I often think as I gaze in awe and wonder at the vastness of space and those millions of bright dots, that if only more people, especially those wielding power on our tiny planet, would star-gaze and contemplate the worlds there must be out there, they would get our problems into better perspective and try to create more loving kindness in our small world, instead of the strife we are constantly inflicting upon each other. For our first month in Canada we lived in a room in the home of a Chinese couple who had a grocery-shop and they also rented off their house to east Indian students who were attending the University of Toronto. The wife did not speak a word of English but always smiled pleasantly and would give oranges to lively little Christine, who was petted by everyone. Mr. Bhatia, one of the students, used to say, with that curious soft lilt the Indian speech has, 'she is just like my own child', the little daughter he was looking forward to being reunited with in India when he had finished his University year. We have generally been lucky in encountering pleasant people and there is a little anecdote, told to Mr. Lowry and myself, by the aunt who is pictured with us, which I think is worth remembering.

'An old yokel was leaning on a fence when some people came by and asked him what the people were like around those parts. He pulled on his

pipe and thought for a minute, then asked, "what are they like where you come from?" "Quite nice", they replied. "You'll find the same here", said the old man. A little while later another group of people approached him asking the same question, and again he queried, "what are they like where you come from?" "Nasty, miserable bunch" was the reply this time. "Yes, you'll find the same here", the old man replied'.

Meanwhile—back in Canada! Jobs were scarce and John was beginning to feel rather desperate, he would have to try car-washing—the only job that appeared to be available at the time. Then on one of his routine applications by telephone, the man at the other end of the line said that he might be able to use him and would he like to come out to Ajax for an interview. Would he like!! Frantically—Where is Ajax? Thank goodness the bus company knew, because no-one in the house had even heard of it. Ajax is on Lake Ontario, about 25 miles from Toronto, and the bus would stop, on its outskirts, by request; leaving John with a perishing cold walk of about a mile and a half to the factory.

The Canadian government representative in England had not been of much use in his advice to we emmigrants. He told us that our English winter coats would be 'just fine for Canada'. My foot! Fine if you are going from home to heated car, and from car to warm building; but to queue for buses, or be out for any length of time in the middle of a Canadian winter, they are useless. The cold, and especially the searching, biting wind that we found Ajax is renowned for, just sailed right through to our bones. Christine, who was a game little creature, cried one day as we tried to brave that penetrating blast to go shopping, and we had to turn back home with her; but she never got bronchitis again and I decided that even if I never had anything else to be grateful to Canada for, I would always be grateful for this.

The man who hired John told him later that he had given him the job because he could understand him. At that time most of the residents of Ajax were emmigrants, even today it is still a very cosmopolitan community and at present John is working with a former Russian, Australian, Korean, East Indian, and a Polish engineer. Such is co-incidence that recently he and the Polish engineer discovered that just

before they left for Canada twenty years ago, they had both worked for The Salford Electrical Instruments Company, in Stockport, England.

Ajax was like an overgrown village—4000 population, and John did not think I would want to live there, having been brought up in a big city like Manchester. But obviously he could not continue getting up at 5.45 a.m. every day to catch buses, followed by a freezing mile and a half walk to the factory in order to be there for 8 a.m.; reversing the process in the evening to arrive home, about 7 p.m. Also the bus fares were quite a burden for our modest income. Fortunately, in Ajax there is a group of small apartment buildings, surrounded by grassy play areas for children, and they had a vacancy in one of the single bedroom apartments. One of my chief concerns about moving to Canada had been, would we be able to find a place to live, or would everywhere specify 'No children allowed', the thought of it used to, literally, give me nightmares. These apartments seemed ideal for us so we happily transferred ourselves to Ajax, and have never regretted it.

I used to write to Mr. Lowry every week and I could tell from his slightly mocking replies that he was not really disappointed that the going was a little hard for us. He used to quote La Rochefoucauld—'the tribulations of our best friends arouse sentiments in us which are not entirely unpleasant', and I think he really hoped we would return to England. But as things improved and we settled down, I found life more leisurely than I had ever known it before.

We moved into the apartments with just the bare necessities, a cooker, small refrigerator, four chairs and a table, a chest of drawers and two beds. I had bought them all from reading the advertisements in the Toronto paper, consulting my street-map, and visiting the various homes where they were for sale. I remember how startled the bus-driver was one day as I attempted to board his bus with a large shopping-bag and an ironing board under one arm and a feather pillow under the other, with Christine hanging on the skirt of my coat. I managed to convince him that it was 'hand luggage'. A few minutes later I hastily struggled off again, having caught sight through the window, of a refrigerator standing FOR SALE on the pavement outside a shop, and the price was the lowest I had

seen, probably because it was pink, not a popular colour for a fridge, but it is still going strong twenty years later and has never needed a repair. The furniture from England did not arrive until later in the year when the weather became warmer and the St. Lawrence Seaway was again navigable for traffic. Alas, we very soon found that the old wooden-frame piano didn't care for the dry atmosphere of Canadian homes and constantly needed re-tuning. John finally bought a tuning-hammer and did the job himself as paying for the frequent re-tuning was becoming too expensive. In due course Christine did learn to play, showing quite an aptitude for it, and later she earned her pocket-money by teaching her little brother.

I had very little housework to do in the clean atmosphere of country, central-heating, and a small apartment; and as the summer drew on we had wonderful outings in the surrounding fields picking wild strawberries, raspberries, blackcurrants, blackberries, apples and pears. This profusion of fruit growing wild was mainly due to the fact that Ajax had formerly been a farming community but at the outbreak of the second world war the area had been requisitioned and a shell-filling factory built, along with homes for the employees. Gradually a thriving community developed and in January 1955 officially became a town named Ajax, after one of the British warships which had taken part in the Battle of the River Plate.

During the warm weather, after John finished work at 4.30 p.m., we would take a lunch and walk to the sandy-shored little creek about a mile down the road, for a pleasant picnic and a swim, while Christine made sand-pies and paddled, or watched the schoolboys who would sometimes be fishing there. What a difference from our lives in grimy industrial Manchester. We were amazed at the glorious profusion of wild flowers and Chris and I had lovely times picking great bunches of them for the apartment. Orange day-lilies, purple asters, blue chicory, enormous red poppies, golden-rod, and many more.

Later, when we bought a secondhand car, we would drive along the quiet unpaved roads around the lake in the evening to watch the various little animals coming out to feed. Cotton tail rabbits, groundhogs, foxes, squirrels, chipmunks, skunks, if we were lucky a deer, and a wonderful

variety of colourful butterflies and birds.

One late afternoon we arrived at the field beside the lake and saw the spectacular sight of thousands of large, beautiful, orange and black monarch butterflies delicately assembled on the milkweed (which stands four to five feet high), in preparation for their winter migration south. Another awesome sight in the spring and autumn is the migration of the Canada goose. A faint clamor will be heard somewhere up in the sky, and as it comes closer and the chorus of honking more distinct, you will see their 'V' formation high overhead—sometimes in dozens and sometimes in hundreds. These beautiful, loyal birds are monogamous, and as they make their long trek they continually honk to each other, reassuring their mate that they are close by. It is sad that if one of a pair is shot down by a hunter, the other invariably becomes a victim too, as it comes in search of its missing mate.

There was a female skunk who decided to make her nest underneath the garage next door; I have never found these creatures objectionable if you leave them alone. They are generally nocturnal animals and one dark night as I glanced through the window, half asleep, there seemed to be something white floating down the garden. I opened the door and peered through the darkness, wondering whether my eyes were deceiving me, then realised that the ethereal, wavering streak, was the white stripe on the back of fat old Momma Skunk, as she meandered along on her evening forage.

We bought peanuts for the garden squirrels and they became so tame that they would take them from our hands. One little imp was so bold that we had to first give him his treat so he would leave me in peace while I hung out the washing, otherwise he would try to climb my leg, and I did not want his soil-begrimed little paws among the laundry. They are so dainty and graceful with their long bushy tails, they appear to undulate rather than run, as they scamper along fences and telephone wires.

Naturally, I was now writing very enthusiastic letters about life in Canada, to Mr. Lowry, and tried to persuade him to come and see for himself, particularly after our first autumn when I realised that the glorious bright colours of Fall, as autumn is referred to here, were not

exaggerated as he and I had once thought them when we went to see to an exhibition of North American paintings at Manchester City Art Gallery; and I wrote accordingly and told him. I know that one of the records of which he was proud was that he had never left the British Isles, but I am sure if only he could have been persuaded that a brief visit abroad would not detract from the image and stature he had by then attained for himself in the world of art, he would have enjoyed the leisurely walks and drives we could have taken around rural Ontario together, just as he had enjoyed driving through the Fylde countryside thirty years previously with Maud, and he might even have been a happier person, because from all accounts, despite his fame and fortune, he remained a lonely man. I missed him very much and often used to dream about him; in them I was always trying to reach him somehow, but he would be aloof and in the distance.

In England John and I had decided that we would not have any more children. Life had been arduous in Manchester with a fractious baby, colds and bronchitis, in a draughty old house, and another child would have been a big strain on the budget. But I had always regretted being an only child myself, and when I found that things were working out so well for us in Canada I really longed for another baby. John was not so enthusiastic, make one objection after another, his final argument being that we had not got a house and I could not drag a baby-carriage up and down apartment stairs. I started househunting in earnest and opposite the school, and just within our means, found the little detached, storey and a half house which we still occupy today. We moved in at the beginning of August 1958, ready for Chris to start school in September, I do not remember what exactly was the first thing we did after moving into the house, but joy of joys, our baby boy was born 14th May 1959, exactly nine months and two weeks later (and the doctor said that he was two weeks overdue!).

We have a beautiful modern hospital in Ajax today, but in 1959, although properly equipped, it was housed in one of the long wooden, shed-like buildings, left there after the war. They were sadly short of space at times and the week previous to Richard's birth there were patients sleeping on stretchers along the passages. I was lucky enough to be

assigned a bed in a ward, and as the orderly pushed my stretcher along from the delivery room we had to pass the glass-fronted nursery. We stopped to admire my gorgeous baby, who was already vigorously sucking his fist, and he said, 'I know someone who would give you a thousand dollars for that baby right now'. I have sometimes wondered since whether he was serious, he seemed to be at the time, but I was blissfully happy.

I remember once saying to Mr. Lowry, when we were still at the Pall Mall Company, that I was not ambitious, all I wanted out of life was a kind husband, a house in the country, two children and good health for all of us and he replied, 'good God—what else is there?'

I wrote to tell him that I had achieved my ambition and kept repeating our invitation to come and stay with us, even suggesting that he bring along a friend, such as Ann, if he did not like the idea of making the journey alone. His reply would be to enquire when were we coming to England. The aunt we stayed with before leaving England is nearly eighty years old now, and she comes regularly every two or three years to visit her daughter and family in Edmonton. She has to change planes at Toronto so we go to the airport and spend the couple of hours interval with her, and see her safely onto her next plane. This year, as we were about to leave home, we received a phone call from her daughter to say that she would not be arriving until the following day. Her mother must have dozed off in the departure lounge at Ringway Airport, Manchester, and missed her flight. We met her the next day at Toronto, still a little puzzled as to how she could not have heard her flight announced, but enthusiastic about the care and thoughtfulness she had received from the stewardesses and other airline employees concerned with her journey. There was, however, one thing about which she was astonished and disappointed (much to our private amusement): they did not have corn-flakes on the plane for her breakfast. Everything else one could reasonably expect for breakfast, no doubt, but, 'no corn-flakes!'—she simply could not understand how an early morning flight could take-off without them.

I used to write and tell Mr. Lowry how she enjoyed her flights, but he would not be persuaded to make the journey by ship or by plane.

There were all kinds of reasons why I was reluctant to visit England, one of them financial. It would have been too expensive for us all to go and too difficult for the family if I went alone. All I could see that was preventing Mr. Lowry, was this fixation about his record of not leaving the British Isles and also he did not like the idea of having a smallpox vaccination. I suppose he might have paid my fare, but I did not feel this would be a desirable arrangement. We lived comfortably but on a very close budget. I made most of the childrens' clothes and my own but this was no hardship, I enjoyed it. I used to say in those days that happiness was eking out enough from the housekeeping money to pay the monthly telephone account—approximately four dollars, so that I would not have to present John with another bill to pay.

In 1966 our son, Richard, was nearly seven years old and I thought it would be nice if I could get a part-time job and earn a little money for a few extras. I was given the opportunity of two full-time jobs at reasonably good pay but I still felt that my first duty was care of the family and being available for the children after school, and ideally, I wanted to do something I could enjoy. The answer was the public library, five minutes walk down the road. Reading is one of my favourite occupations and this was something else I was finding I had far more time to indulge in, than I had in England. A position became vacant on their staff soon afterwards, and I had the good fortune to secure it. Fifteen hours a week at sixty-five dollars a month, not a fabulous sum, the full-time jobs had offered far more but the library was exactly what I wanted—availability for the children and a little extra cash. I found the work interesting and I have been there ever since. The town has grown considerably, now 19,000 population, the library to over fifty thousand books, and also my salary; but as I remarked in a letter to Mr. Lowry, one works to get the money to do some of the things one would like to do, but then finds that one has not the time to do them. I find this particularly depressing at the present time, the reason for which will become apparent as my story continues.

My daughter was a good student and had been accelerated by one year at school, something for which we were particularly thankful as things worked out. In October 1969 the high school invited several young

United States citizens, who had come to Canada in protest against their own country's foreign policy, to meet and talk with the 'Man in Society' class, of which Chris was a member. They were not yet eligible for work permits in Canada and were living a rather sparse existence on their dwindling savings. Despite her tender years my self-willed young daughter fell in love with one of them and decided to leave school and get a job, to help support them I suppose, and she went to work in a large department store in Toronto.

All this happened in the space of two weeks. Our protests were in vain, she left home and John gave permission for them to get married, although I opposed it. Theo's parents flew up from Los Angeles, expecting to witness their wedding only to find that the Bishop of Toronto, through the intervention of my ally the Vicar, had forbidden a priest outside our parish to marry them. Mr. and Mrs. Pettepiece were very nice people, quiet and reserved, not at all the popular British conception of Americans. They were disappointed, and after a couple of days in Toronto they returned to California. I was sorry and felt like a dreadful ogre.

Chris phoned us on November 26th to say that she and Theo were going to be married the next day at City Hall in Toronto and would we like to attend? I went alone and felt as though I was being crucified. Christine was a month short of her seventeenth birthday and Theo was twenty-one years old. They were living under very grim conditions in a tumbledown hut, on her meagre wage, but they had made their own choice. However, just before Christmas Mr. Pettepiece came to Toronto again on business and persuaded Theo to return home with his bride and not only support, but also to send her back to school.

Theo and Chris left for Los Angeles on December 15th. In retrospect these details sound so matter of fact but at the time I found them heart-breaking. Apart from the disappointment of such an early division in our little family, and all it entailed, my vehement opposition to it all had hardly endeared me to any of them, and now that they were going to live so far away, as Christine said when she phoned me from the airport, it might be years before we would meet again. Thank goodness this did not

turn out to be so.

From Los Angeles she wrote glowingly of his parents, his brother (who is a clergyman), their home with a view of the Pacific, and the glorious warm weather; the schooling she was not too enthusiastic about, although she continued to get good marks.

We were so happy when shortly before Easter Theo's parents very kindly invited us down for a visit. When we got there Christine was nearly bursting with the news that she was going to have a baby at the end of October. Theo's parents were delighted at the prospect of a grandchild, but my deflating remark was, 'what about school?'. To everyone's relief she was able to finish the semester, and obtained her High School Certificate.

We had a delightful holiday in the California sun, visiting so many of the tourist attractions which formerly we had thought would never be within our means. The zoo, Marineland and fantastic Disneyland; Richard was ten years old now and we all thoroughly enjoyed ourselves. The Pettepiece family could not have been more kind and took us for lovely drives along the spectacular California coastline, and to the Huntingdon Library and Art Gallery in Pasadena, where are housed the Gundulf Bible, one of the last written by hand, many beautiful paintings by old masters, antique porcelains, sculptures, etc. Theo's family were all musically inclined and each of them played at least one instrument. In the living-room they had a large Hammond organ and a piano, so Christine started to play again, and Theo coached her on the guitar.

We returned to Ontario on April 1st and the weather threw down everything it could that day—rain, mist, hail, sleet and snow and John wished that we could remove ourselves to California permanently!

A few days later I wrote to Mr. Lowry, telling him about our wonderful holiday and how glad we were that things had worked out so much better for Christine than anticipated, just as previously I had written telling him all the harrowing details of her leaving home and living a very impoverished existence on her modest pay in Ontario. I have always been completely honest with him and felt that I should be frank now so that he would not retain any false hopes of me going to England,

and he might be persuaded to come to Canada himself after all. I therefore told him that the money I earned in future would be used to afford us an annual reunion with our daughter and grandchild; and that is pretty much how it has worked out, even though they decided that the child, a boy, Devin born October 29th 1970, should be born in Canada, they still live three thousand miles away on Vancouver Island. This is the great sorrow of my life, that I can see so little of them, the old business of earning the fares depriving one of the time. Sadder still, kind Mr. Pettepiece died of a heart-atack two weeks before his yearned for grandson was born. One of the last things he said was, 'tell Chris to look after that baby for me'.

I had been working in the library for over ten years by 1976 and I renewed my passport for the first time, with a view to spending two weeks with my daughter and two in England, but I was too late—Mr. Lowry died in February. Perhaps he would not have wanted to see me, I will never know now. He once told me that his mother, who was the greatest influence in his life, used to say, 'when a chapter is closed, do not re-open it'.

In years gone by Mr. Lowry had implied that I would benefit under his Will, but he had always disliked and had spoken with annoyance about antiques, etc. being removed from Britain, especially to go to America. He had an aversion to Americans in general, considering them loud, boastful, and overbearing; so once I became firmly established on this Continent I felt sure that none of his treasure would ever come to me, and had supposed in any case that since he had no close relatives the greater part of his estate would be used to set up a museum or scholarships. Therefore I was surprised, as were many people in the art world, when I learned after his death, that most of his estate and treasures were to go to one individual, and pitifully few to the public galleries (which would have assured that they will remain in Britain). I suspect he may have been badgered too much while he was still alive by the jockeying for first place by the various galleries, and he became tired of the whole thing.

It may be co-incidence but he made his last Will on May 6th 1970, soon after he would have received what I now suspect he felt was a very selfish and unfeeling letter from me, and I feel troubled and guilty that

perhaps a visit from us might have meant far more to him than we had supposed, and my seeming lack of affection might have hurt him very much. Except from his mother, warmth and affection are things he probably experienced little of during his long lifetime, perhaps his own restraint inhibited those with whom he came in contact. As for myself, I had affection and loyalty, but one set had to take precedence over the other. He did not bequeath me even a memento. 'Cut me off without a sausage', is the way he would have put it!

As he became increasingly famous, people would write to him wondering whether they were related. He was rather cynical about this and would remark sarcastically—'You'll never guess what—some more relations have "discovered" me!', and he would laugh derisively. He first became acquainted with Mrs. Spiers (née Carol Ann Lowry) who is his beneficiary, shortly before we left England, she was a schoolgirl, about ten years old at the time. She bore the same name and was interested in art, so wrote to him accordingly. He showed her letter to me, and as they lived not far from Mottram, he decided to pay them a visit. I suppose she and her widowed mother helped to fill the gap we were leaving in his life, later he often mentioned her in his letters to me. At first he had said that he was quite sure they were not related, then he wrote jokingly that she must be related, 'because she dislikes work as much as I do!' But in a letter dated 6th July 1957 he writes, 'I went to a Quaker service with my newly found relatives in Clitheroe (and that they are my relations is proved beyond question)'.

I have been surprised to learn that he kept photographs and letters of mine, some of them many years old. I had continued to write to him but less frequently since he did not reply, and always sent him a birthday card on November 1st. I used to try and find something to amuse him and would mark up the price on the back of them by a shilling or so, or make a note that I had 'rubbed it off', because I knew he would turn it over, as I had seen him do many times before, and he would say with a laugh, 'how much am I worth spending on?'

Although Mr. Lowry did not write, Mr. Openshaw and I have continued to exchange the occasional letter and when he and Mr. Lowry

happened to meet, Lowry would say, 'I really must write to Doreen', but he never did.

Recently I was re-reading a letter Mr. Openshaw wrote to me in 1973 and he reminisces as follows:– 'The Pall Mall office was always such a happy and unique place. G. P. Fletcher, with his unconscious humour like advertising, "Windows to Back Turner Street" [Back Turner Street being a dingy, narrow alley—not at all the attractive vista one might have supposed from its mention in the advertisment] and telling us of all his friends who were ill or dead and then adding, "and I nearly had toothache last night": and warm and friendly Mr. Taylor who made the office tick whilst always seeing the funny side of everything. And you and I completed a staff the like of which simply couldn't have been as happy anywhere else. We were lucky to have been so privileged'. And in a more recent letter:– 'I like your reference to his unrestrained wholehearted laughter. I'll never forget the journey back by train from the office picnic; as we reflected on the scrappy meals at the Tamil, the baby's rusk, the child's meatpie [their appetites had not been satisfied and they were threatening to steal these little lunches of the two infants we chanced to meet], and into the bargain having to pay our own train fares. Mr. Lowry and I were completely helpless with laughter, almost breathless, with tears streaming down our faces. What a pity that Mr. Fletcher never organised another picnic!'

Mr. Fletcher was such a dear but his life was rigidly ruled by the clock. He arranged that we should have an office picnic to Chester, out of sheer goodness of heart; but as we took what should have been a leisurely walk along the walls of that ancient city, he would keep having a surreptitious look at his pocket-watch, because if we upset his meticulously pre-arranged schedule, it would quite spoil his day. Naturally, we mischievously ambled a little slower, just to tease him.

We finished up the days' outing at a cinema which was showing an American movie. Mr. Lowry came with me once to see the film version of Shakespeare's *Richard III*, starring Sir Laurence Olivier, and enjoyed it very much, but generally speaking he abhorred films, and on this occasion he kept muttering, 'God, it's awful', and rushing out to admire the

fountain in the foyer; much to the amusement of the usherettes, although he said that they agreed with his comments as to the quality of the film.

No wonder dear old Mr. Fletcher did not give us another picnic!

There is something, however, for which I would reproach Mr. Lowry. He and Mr. Openshaw and myself had lots of fun together, and there was a longstanding joke between us about, 'will you come to my funeral?' 'Yes, if they bury you with ham and tongue'. 'And when they ask, "what did he die of?", we'll say he died of a Tuesday!'. Mr. Lowry would close his eyes, lean back and solemnly place his hands across his chest, and we would all roar with laughter—odd though it may sound relating it now. Sometimes, with jocularity barely concealing anxiety, he would ask would we make sure that his name was inscribed on his parents gravestone, which he had shown to me on my wedding day. 'Even if there is only room to squeeze it down the side', he would joke. But attendance at his funeral was by invitation only, and Mr. Openshaw was not invited.

He was not a churchgoer during the time I knew him, except on very rare occasions (he came to Christine's christening), and I do not know whether he prayed, but he did show some concern for a friend who was an atheist and who called his dog, 'Gentle Jesus'. He mused, 'what will he think right at the end? I wonder what it is all for, nature never wastes anything, you know'.

An aquaintance once asked me, when I was speaking about Mr. Lowry with my usual warmth and enthusiasm; 'was he your lover?' Then recently someone asked me, 'were you in love with him?' I do not believe Mr. Lowry ever had a real romantic attachment to anyone, but there was a warm avuncular affection between us. Yes, I loved him dearly.

P.S. If Mr. Lowry knows how I've worked on this—'like a galley-slave', —to use an expression he was fond of, he will be rolling around laughing to himself, wherever he is!

Afterthoughts

Towards the end of 1977 a lady who was doing some research on Mr. Lowry, phoned me from England and I suggested that she contact Ann and Margeret whose London home was in the Albany, an address which a personal enquiry should easily have pinpointed. I also suggested Mr. David Carr whose lively friendship he had enjoyed so much in the forties and fifties. Lowry had one of Mr. Carr's pictures hanging in his bedroom, I pointed out to him that the man in it had six fingers on each hand, but Mr. Lowry did not think it mattered.

In May 1978 she phoned me again and I enquired for the addresses of Ann and Margeret, because I still hope to meet them one day. She had followed through the various clues I had given her with regard to Margeret, and Ann and her parents, and had enquired from Mrs. Carr (unfortunately Mr. Carr died in 1967; the Carr's biscuits/Peek Frean family). Mrs. Carr remembered that Mr. Lowry used to talk about someone he called 'the child' with whom he went to concerts in the forties, 'that would have been me, but she knew nothing of the other two.

I suggested Margo Ingham to her. She used to have the Midday Studio in Manchester and I had been there several times with Mr. Lowry so I thought it likely that Ann would have been there with him also. Apparently Margo Ingham had died very recently and her husband's death preceded hers by a couple of months. Mrs. Swindells, who was his house-keeper from 1948 until his death, had also died.

The lady thought it odd that although Lowry kept notes and cards from various people (one of whom was Howard Spring who asked Mr. Lowry, in the forties, to illustrate one of his books, a request which Lowry declined) there was no correspondence of any kind from either Margeret or Ann. I do not think this particularly unusual as I do not remember

sending him even a card when we lived in England, because we saw each other so frequently.

The nasty thought was just beginning to creep into my mind that perhaps she thought that Ann and Margeret were figments of my imagination. Then he asked whether he ever mentioned Maud to me. Well of course he had, at great length, and anecdotes about her parents as well. How he admired the imperturbability of her father, whether he missed a train and had to wait a day for the next one; or when, through the misunderstanding of his gardener, he found that his beautiful lawn had been ploughed up to make a flower-bed. And did not become exasperated or remonstrate, but quietly requested that it be restored to its former condition the following year.

Apparently Lowry had talked about Maud with other people too, even showing them the house where she lived in St. Anne's. The tenants of the house had been traced back to 1905 yet nobody with a daughter by the name of Maud had ever lived there! She had even advertised in local papers for anyone who might know of these people but so far nothing had come to light.

I have, of course, condensed the stories of Margeret and Ann. Margeret was even supposed to have a younger brother who died before he knew her, and I heard all about Miss B 'smoking like a chimney', and the fantastic fully automatic washing-machine which she bought for Margeret's mother. It was like a serialised novel, and I enjoyed every chapter as we sat around the fire in the evening and he talked about where he had been and the activities of these people who had such interesting lives, compared to my own humdrum existence. There were stories about other people too. I know some of the principle characters are real because I have seen their names linked with his in the newspapers, but were the stories true?

How appallingly sad if he had to make them up to fill his lonely life and make it appear that he had the comfort of lots of friends, or if he felt he had to be entertaining in order to be welcome so frequently in our home. How awful if we were his only real intimates. When I remember that I had no qualms about leaving him in 1957 as I thought he had Ann and

Margaret, and said to him, 'you are alright now', he replied, 'you don't understand'. What did he mean? If these people were purely imaginary, it is unbearably sad to wonder what his feelings really were at that time. I am thankful that Carol Ann Lowry and her mother came into his life at this point, and I fervently hope that he developed some of the intimacy with them he enjoyed with us.

The evidence seems to show that a number of his stories were just fantasies. Those who seem to revel in the denigration of well-known personalities after their deaths have called Lowry a liar. In this he is to be pitied and not blamed. He was rooted in insecurity and had a desire to be accepted. His lies were not harmful, no one was injured by them. He was never malicious and perhaps his stories were created simply as a form of protection for himself against mockers and scoffers.

Further derogatory remarks have been made about Lowry's supposed nasty obsessions with look-alike girls in both his paintings and his private life. This is absolute calumny. Has any of the young women he befriended even hinted that his behaviour was other than correct towards them. Although I was not exactly a 'look-alike', being blond and blue-eyed in my youth, whereas they were all dark-haired, I saw him almost everyday for years and knew him well. Many artists including Leonardo da Vinci have had apparent fascinations with a particular facial characteristic and in Lowry's case I can only surmise that he had an ideal female type that he reproduced on several occasions throughout his life.

Some have interpreted his looks at the painted mini-skirted girls of the 1960s as leers (an interpretation from which they no doubt received vicarious pleasure). Why shouldn't he have looked at them. He had an artist's observant, interested eye and he was concerned with the changing fashions of his times even if they seemed strange and humerous. If young girls were dressed to attract it is hardly surprising that Mr. Lowry did notice them, but he was not the only one.

In February, 1981, I received a newspaper article about a book written by a lady who knew Mr. Lowry during the last fourteen years of his life. The startling appearance alone, of this lady would have filled the Lowry I knew with unease. Wearing bright green nail-varnish, eye make-

up and numerous heavy rings was how the newspaper described her. He would ridicule and make fun to me about women who wore heavy make-up, saying 'she has a complexion that comes and goes—it comes in the morning and it goes at night', and wonder whether it would crack if they laughed.

With regard to the 'meanness' of which he has been accused, nothing could be further from the Lowry I knew. I found him to be a very kind, thoughtful, warmhearted person, from the little things like bringing me his chocolate ration, making me presents of ornaments I admired (and could not afford), playing with my baby and doing the dishes, to buying a piano because he thought John missed his piano-accordion and that Christine should learn to play later. I am sure that he would have covered the cost of her education had we stayed in England (and I would have allowed it), instead he substituted Carol Ann Lowry who was a poor little girl living with her mother in a flat over a shop, when he first met her. Even when we were leaving him behind and going to Canada and he realised that I would like to take some of my furniture and ornaments along with me, but John was baulking at the cost, he gave us a cheque to cover the whole amount. In fact I became very careful as to what I admired or expressed a wish for as he would so often supply it. I remember too how during my mother's last illness, that each morning for nearly six weeks he went down his garden, through the damp grass, to gather bunches of flowers as he knew they would please her, and braved the conspicuous picture he must make on the bus with them, probably feeling rather embarrassed since he did not relish being thought odd in those days.

All these things he did voluntarily and gladly because he knew (to use one of his phrases) we 'didn't always have our eyes on the main chance', we were glad to see him for himself, yet on the other hand he did not want to be a liability to us by his frequent visits.

He used to tell me how people would ask him to dine with them in a restaurant, then each would wait for the other to pick up the bill. The way he would tell me it sounded as though it became almost a game with him. He felt that they had invited him for a purpose of their own, many also

would have had some allowance made for expenses, so why should he foot the bill for the privilege of being used. Maybe he used to tell me to try and justify himself to himself, I do not know. As he got older he could have become overly suspicious and his reaction more exaggerated. Yet if to some he was so obnoxious that his presence was a chore, why did they put up with him? Perhaps as he became more famous they wished to use him for his position as a celebrity. He was very shrewd, and knowing how he felt about the people who were beginning to search him out when we last saw him, I am not really surprised at his behaviour towards them. He knew that such people would probably have had no time for him in the early days, more likely would have scoffed at him. This is one of the reasons why he never risked telling any of them that he had had a permanent job as an office clerk.

He treated the people who befriended him before he became famous, with kindness and respect but even these, if they attempted to capitalise on the friendship later, wanting something 'on the cheap' for instance, he would lose some of his regard for them.

With regard to his own view of himself as a painter I have the impression that he painted simply because he felt like it. He always insisted that he had no message, that he was the first one to paint the industrial scene seriously and that others might follow after, perhaps even do it better, but he was the first. I do not think he would have liked to have been thought part of any school, rather that he was the first in his own field. He was very interested in the genuine struggling young artist and would try to meet and encourage not only by words but in a practical way by making a sale for them, even though his own means were still comparatively slender. He scoffed a little at the affected appearance and Bohemian lifestyles adopted by some students, who seemed to think that acting the pre-conceived notion of the part would make them better artists.

There is a sad sequel to what I feel is still essentially part of my story of Lowry, because it reads like one of the tales (many of which I now doubt the truth) of unusual people and their experiences, with which he used to entertain me. But this tragic story I know to be true because it was

splashed across the front pages of the English newspaper in August of 1980.

Carol Ann Lowry married a fairly wealthy man, sixteen years older than herself, by the name of Spiers. He was a property developer, also a competent pilot and owned his own airplane. They had two homes, one in Kent and the other on the Isle of Man. In August 1980 they had acquired a larger aircraft so that they could take their two children, a seven weeks' old baby boy and a three year old little girl, along with them on their trips.

On the morning of Saturday August 2nd, they were crossing the Irish Sea from the Isle of Man to the mainland, when they developed engine trouble and had to ditch in the sea. Carol Ann was sitting beside her husband with the baby on her lap, the little girl was in the seat behind. None of them were wearing lifejackets although they had them in the cockpit. Carol felt herself being sucked from the aircraft and the baby from her arms. The last she saw of her husband and little girl was him trying to get her out of the back of the aircraft.

Carol Ann had never learned to swim and she felt herself going down, down, down. Just when it must have felt as though her last moment had come, she re-surfaced and miraculously, so it must have seemed, close enough to grab a piece of floating wreckage. There she bravely clung in that bitterly cold water for close to ten hours, with heaven knows what terrible thoughts going through her mind, but I suppose praying that the same miracle which had thrown her up to a piece of wreckage, might have been at least kind enough to do the same for her husband and daughter. This, however, was not to be. She never saw either of them again.

Many hours later she was rescued, but I wonder how well she feels it was worth surviving such a terrible ordeal and loss.

As I write this now in August of 1981, I am holidaying and sitting on the verandah overlooking trees and lake, to the mountains beyond, of my daughter's lovely little home which is now near Duncan on Vancouver Island. My ten year old grandson, Devin, is playing in the garden; my son Richard in Ontario is in his last year of University, and John and I look forward to a modest retirement in a very few years time, God willing.

It has not been a particularly easy life and I do wish that I could see

Chris and Devin more often than once a year, but how rich I am by comparison with the wealthy Mrs. Spiers.